iPhone Photography for Everybody
Artistic Techniques

Create Pro Quality Images

Y0-BDD-174

Published by:
Amherst Media, Inc.
PO BOX 538
Buffalo, NY 14213
www.AmherstMedia.com

Publisher: Craig Alesse
Publisher: Katie Kiss
Senior Editor/Production Manager: Barbara A. Lynch-Johnt
Senior Contributing Editor: Michelle Perkins
Editor: Beth Alesse
Acquisitions Editor: Harvey Goldstein
Editorial Assistance from: Carey A. Miller, Roy Bakos, Jen Sexton-Riley, Rebecca Rudell
Business Manager: Sarah Loder
Marketing Associate: Tonya Flickinger

ISBN-13: 978-1-68203-432-3
Library of Congress Control Number: 2020934901
Printed in the United States of America
10 9 8 7 6 5 4 3 2 1

AUTHOR YOUR iPHONE BOOK WITH AMHERST MEDIA

Are you an accomplished iPhone photographer? Publish your print book with Amherst Media and share your images worldwide. Our experienced team makes it easy and rewarding for each book sold and at no cost to you. Email submissions: craigalesse@gmail.com.

 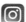

www.facebook.com/AmherstMediaInc
www.youtube.com/AmherstMedia
www.twitter.com/AmherstMedia
www.instagram.com/amherstmediaphotobooks

Contents

About the Author. 4

1. With Beauty Around Me 5

2. Classroom 19

3. Features 30

4. Food 36

5. Portraits 41

6. Mississippi 47

7. Selfies 68

8. Travel 78

9. Kiddos 94

10. Personal Vision113

Index126

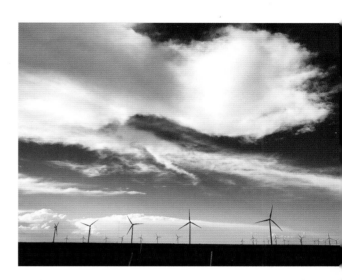

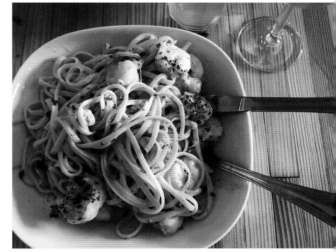

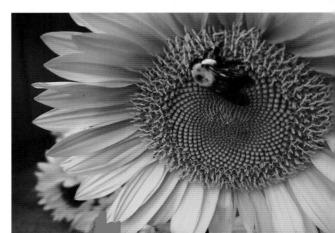

About the Author

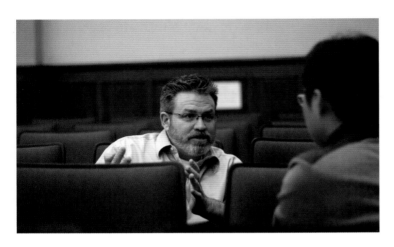

Michael Fagans enjoys telling people's stories. His journey has taken him to the Navajo Nation, Malawi, India, Afghanistan, Scotland, Austria, Canada, the Dominican Republic, Belize, and Guatemala.

Michael graduated from the Rochester Institute of Technology and currently works as an assistant professor at the School of Journalism and New Media at the University of Mississippi. He has worked in the nonprofit sector with the United Way of Kern County and served as coordinator for the Kern Coalition Against Human Trafficking. He was also employed by the newspaper *The Bakersfield Californian* and focused on multimedia, video, and web projects.

Michael is the co-producer and director of the documentary film *The Trafficked Life*. He is also the National Press Photographers Association Photographer of the Year for New York State and Ontario and Quebec provinces. He is married to the Rev. Deborah de Boer and lives in Oxford, MS, with their daughter, son, and cat.

Acknowledgments

An enormous thank you to my wife, who handles being married to a photographer with grace. Big thanks to my brother, Joshua, for collaborating with me, encouraging me, and inspiring me. Much love to Mum and Da for creating the spark. Thank you to Nalani and Chai for providing daily reminders about why life is precious. This could not have happened without all of my photographic mentors, known and unknown, named and unnamed, and my colleagues at the School of Journalism. Thank you.

With Beauty Around Me

At the start of my career in photojournalism, I had the opportunity to work at *The Gallup Independent* in New Mexico. In addition to a paying job, one of the benefits was covering the Navajo Nation. For a New Yorker and long-time resident of the northeast in general, it was culture shock, to say the least. I soon learned to be quite focused on seeing and soaking up multiple cultures.

My apartment was on Nizhoni Boulevard, and I came to admire how our Navajo sisters and brothers saw the world and approached life. I even had the opportunity to document the end of a blessing ceremony; I am not even sure that was for the newspaper.

Something that has stuck with me through the years is to find and appreciate life where we are. Too often, I think, we are waiting to have the right equipment, travel to the right place, or for our children to be in the right mood. We are never satisfied with where we are now; we are always looking to the past or the future instead of living in the moment.

My wife and I differ in the way we respond to enjoying and experiencing moments. She likes to quietly soak them up, while I prefer to make images and document the people, places, and events around me. Part of the problem is that I sometimes disappear into the photography rabbit hole, where time seems to pass at a different rate for me. Our children just seem to accept this, though I am sure that they mutter under their breath and keep walking.

Our son has been holding objects up to his eyes for some time, like me. Though he is only 3 years old, he has a penchant for art directing and telling me what to photograph. I enjoy seeing the world through his eyes, and I remember experiencing that when I went on walks with our daughter, often on our way to her elementary school. Seeing things for the first time—really *seeing* them—is a special, powerful experience.

The photographer Jay Maisel said, "It's always around. You just don't see it." My goal in writing this book is to encourage you to see it, whatever "it"

"Put the book down right now and walk out the front door of your residence. I'll wait."

might be for you on that day, and to create the best-possible images to document it.

This first chapter features images I have made in everyday life. I didn't necessarily travel anywhere amazing or interesting. One was even made on the front steps of our house in Oxford, MS.

Heck, put the book down right now and walk out the front door of your residence. I'll wait.

Well, what did you see? Did you bring your camera? Did you make an image?

My first book was all about how the iPhone saved my career and revitalized how I saw things and made images. I always had my iPhone with me. It fit in a pocket, so there was no excuse not to have it. So, readers, there is lesson one: *Always have your camera with you.*

Walking in Beauty
(closing prayer from the Navajo Way blessing ceremony)

In beauty I walk
With beauty before me I walk
With beauty behind me I walk
With beauty above me I walk
With beauty around me I walk

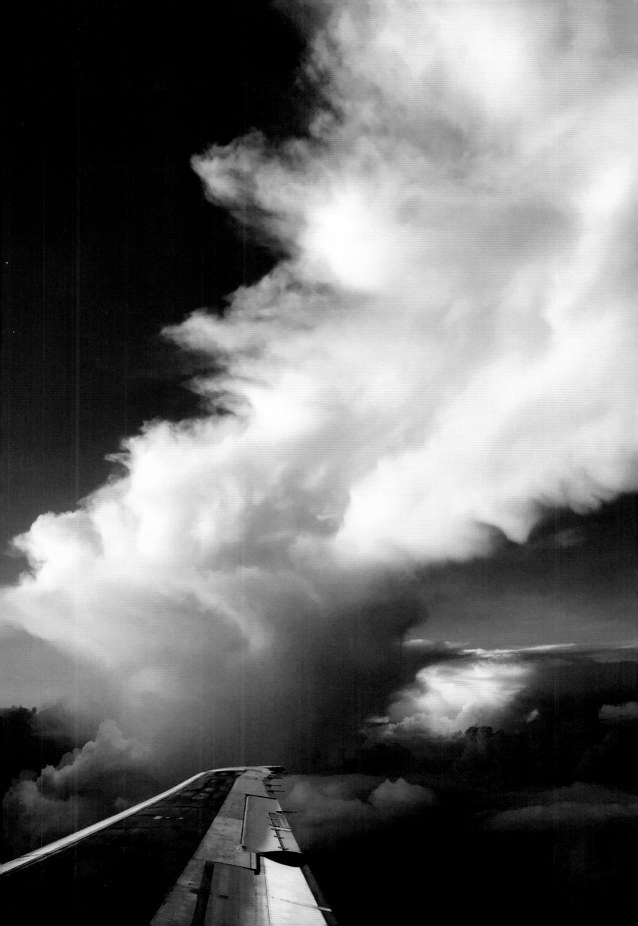

Small Town America

(top) Downtown Oxford, MS, has worked to retain the charm of small-town America. In the square downtown, it's common to find vignettes that lend themselves to photos.

Here, the color palette of a local business simplifies and unifies the shapes in the frame. The pink connects round shapes with the rectangular lines on the lower-right side of the frame.

From My Front Door

(bottom) I made this image upon walking out the front door of our home. I looked up and saw the tress silhouetted against the backdrop of the clouds on the blue sky and paused to make some frames.

Our son, 2 years old at the time, was pulling on my leg to go walking with him, so I did not spend as much time composing the image as I might have.

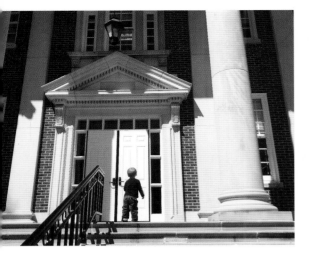

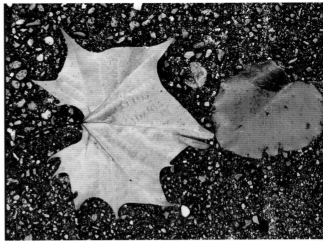

Independence

(left) Timing is everything. Well, framing is very important, too. Our toddler likes to do things on his own, so when he forged ahead, I pulled out my phone.

Consider the design elements present in the scene you are about to photograph. There are many effective compositional elements at work in this image: the leading line of the railing, the framing of my son's body in the doorway, the dark color of his clothes juxtaposed with the light tone of the door, the contrast of the door and windows, and the strong vertical lines of the School of Journalism and New Media's Farley Hall.

Self-Assignments

(right) My colleague, Colin Mulvaney, has mentored me from afar and in person throughout my career. He's made it a point to shoot a frame for himself during every assignment he takes. While I am no longer working for a daily newspaper, I appreciate the disciplined approach Colin takes to capturing images. I shot this image of two leaves in the faculty parking lot on a wet, fall day. It's a simple composition, but the frame is full of color, shape, and texture.

"Think about the design elements present in the scene you are about to photograph."

Fresh from the Market

(top) I love farmers' markets. I like to know who grows the food I feed our family and to form and maintain relationships. We went through a phase when

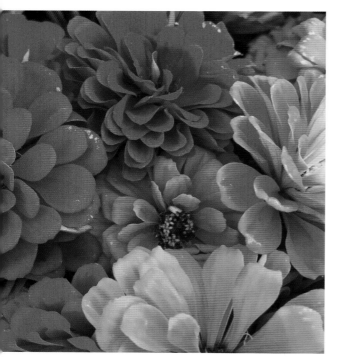

my daughter had a flower or an arrangement in her room almost every week. There's nothing like the color riot of a floral display in beautiful morning light.

Room with a View

(bottom) I made this image from my office desk and never left my chair. Photos can be made anywhere, as long as we are looking. Strong afternoon light, windows, reflective surfaces, and a corner of a room work together in this photograph. I'm fairly sure that's my head at the bottom of the frame. I particularly like the play of light and dark over the various surfaces.

"Shoot in early-morning light to amplify the color in your images."

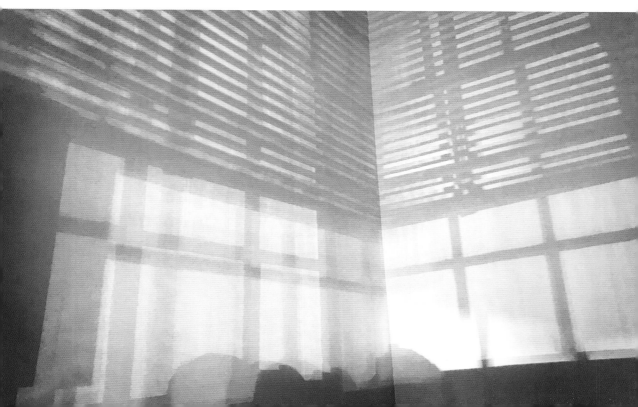

Dancing in the Rain

(top) Here is my daughter, enjoying a monsoon-like rainfall. Her body language and jubilation make me smile to this day. The fact that she is much taller and older now and her joy is more moderated makes this visual record important to me as a father.

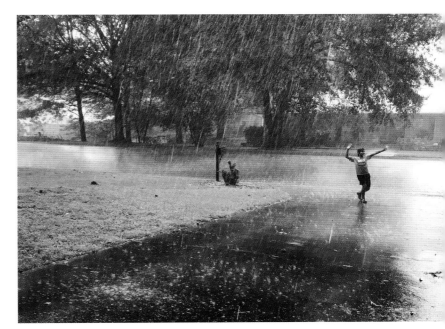

Color and Whimsy

(bottom) You never know when you will come across something that catches your eye and compels you to capture an image. We were visiting a colleague and her daughter when I saw the child's raincoat—and one for the girl's doll—hanging on a closet door.

The color contrast helps this image. I also like the number of questions this photograph raises. It easily engages the imagination.

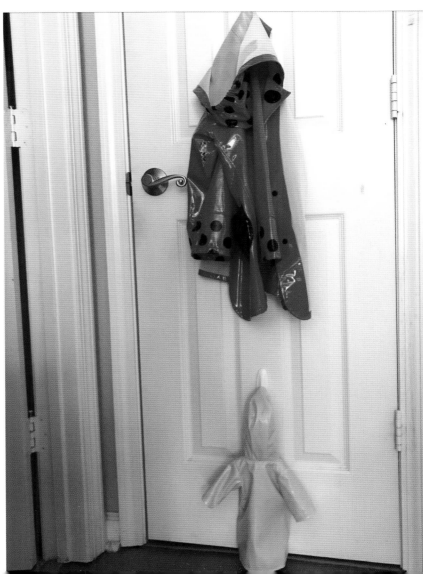

Glistening in the Sun

(top) I made this nature photograph when I came to campus to interview for my current position. This common camellia was outside The Inn at Ole Miss. The water drops on its petals and leaves glistened in the sun.

I opted to isolate one flower, which was nicely set off by the dark-green foliage in the background. Complementary colors are one of the elements in the photographer's artistic tool kit. They draw the eye and can strengthen a composition.

I might have used a macro lens for a closer shot, but I like to travel light.

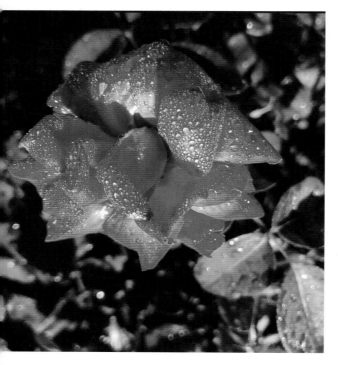

Vignette

(bottom) I was teaching an adult continuing education class in smartphone photography at Bakersfield College before we moved our family two-thirds of the way across the country. The Levan Institute offers a variety of fun, educational classes for the Bakersfield community.

I suggested that we go outside to make some images. I saw this lone flower in amazing evening side light and took a series of photographs before looking for my students.

At the end of the photo walk, the light was gone, and this was just a quiet flower in a courtyard, as opposed to this wonderful scene.

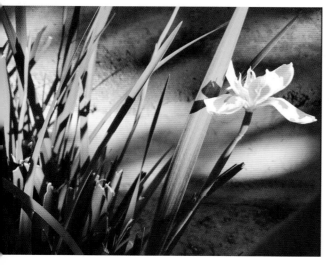

An Artistic Challenge

(top) I made this image in response to a Facebook black & white photo challenge. I was in a fast-food restaurant with my daughter when a deluge hit the town we were in. As we used to say at the newspaper, bad weather makes for good images, and this photo illustrates that point.

Using the focus control on my phone helped make this a more interesting image.

At the Lake

(bottom) This is not a particularly interesting lake, and the light is flat, but the trees and duotone aspects of the image work well together.

I enjoy the mental gymnastics required to really see what is in front of me and make an interesting photo.

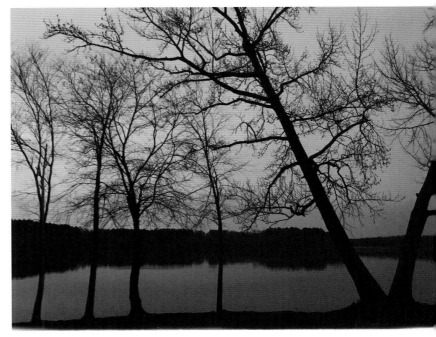

"Take part in social media photo challenges. They can help you come up with new ways to see the world around you."

Succulent

(top) The husband of one of my colleagues runs a delightful little restaurant in town. During a visit, my eye was drawn to this little succulent in evening light. It was too good a photo subject to pass up.

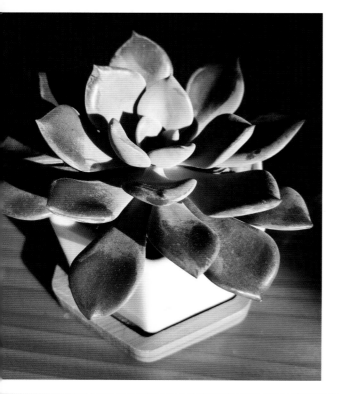

The light falls off in the background, and this keeps the viewer's eye on the plant. Evening light is wonderfully warm, and in this image, the wood table reflects the soft energy of the moment.

Vista View

(bottom) What I love about cycling is that I can cover more ground than I do when running, and it is kinder to my knees. When we lived in California, the vistas I could reach with a little pedaling were an enjoyable side benefit. I am still grinding away in Mississippi, but the views aren't quite the same.

"Capture close-ups and sweeping landscapes with your iPhone."

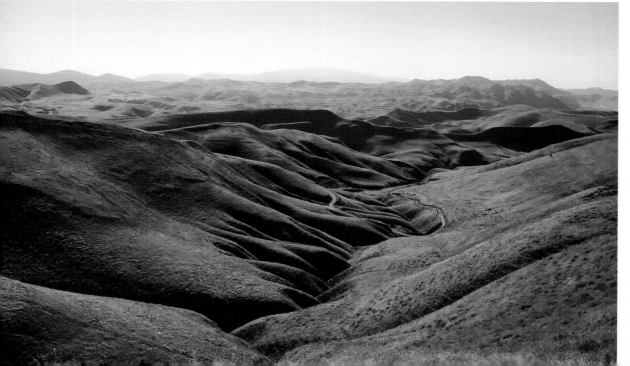

Custom Job

(top) My friend Zach Griffin custom painted my road bike. It is now red, white, and blue. On a 4th of July ride, it seemed a crime not to stop and take a minute to make this image.

A patriotic farmer had painted his gate in this manner, and it called to me. I don't often split the frame in two with a horizon, but in this case, I felt that the sky strengthened the overall composition.

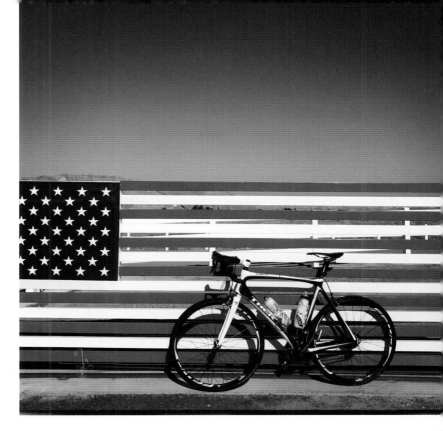

Variation

(bottom) We often accuse folks in our family of "creative listening." Once, I did not accurately hear what campground we'd be staying at. I had a work obligation and, afterward, started out, at nighttime, to find my family. It turns out, I was off by tens of miles and spent the night in my car—but fortunately, I also managed to capture this image while en route.

Luckily, I got a ride to the camp before my wife drove out of the park to call me and give me directions.

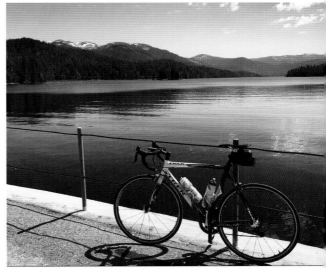

I am a fan this image. Upon reflection, it occurs to me that I seem to have a preference for this color scheme in my bike photos.

Springtime

(top) The University of Mississippi has won many awards for its picturesque campus. It delights visitors, students, and staff throughout the year, spring, summer, fall, and winter. These stunning spring blossoms in the sun were too pretty for me to pass up.

Diagonals

(bottom) Take the time to stop and smell the flowers—or at least *photograph* them. I like the strong diagonal line of the hill in this image. Too often, photographers get caught up in working with vertical or horizontal lines and forget to rely on other options to add dimension and interest in to images.

The repeating shapes of the fence posts and leafy tress in the background of this photo add interest.

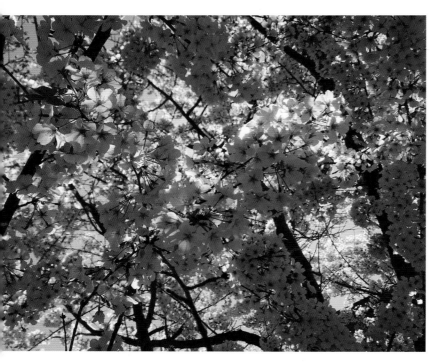

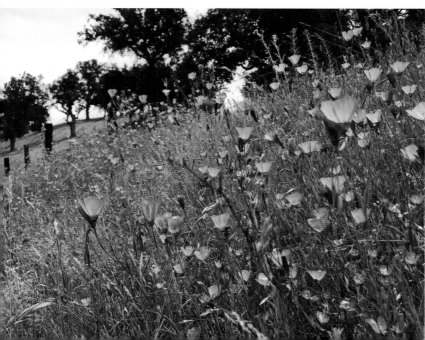

Strong Light

(top) Flowers in strong afternoon/early evening sun appeal to me as a photographic subject—especially when I am waiting for my meal to arrive at the table. Yes, there are times that my wife would like for me to pay more attention to her and our family, but so many things catch my eye and call out to be photographed.

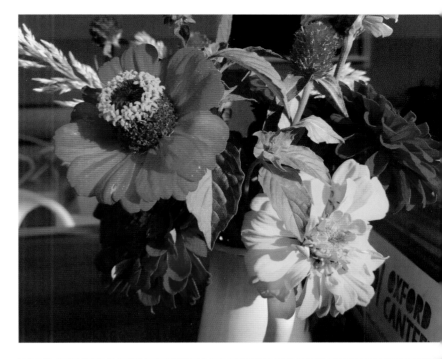

Closeup

(bottom) The water drops on these azaleas were lovely. I got close to the flowers to make this image; this caused the background focus to drop off, which put more visual emphasis on the subject and enhanced the image. I made sure that there was nothing in the background to draw the viewer's eyes away from the main subject.

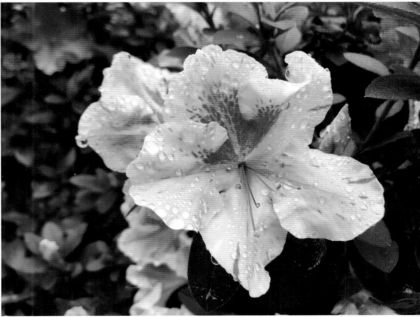

"Scan the scene and eliminate distracting elements from your photos whenever possible."

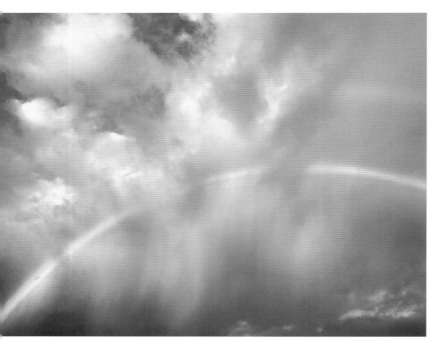

Rainbow

(top) We were at our daughter's soccer game when this rainbow appeared over the fields. I tried various approaches to capture this scene, and this was the most appealing shot in the series. I like the start of a second rainbow, the blue sky in the top-left corner, and the way the sun illuminated the clouds beneath the main arch.

Summer Fun

(bottom) After a good day of editing at a workshop, we had dinner and bubble fun on the shores of Lake Ontario. I can't say enough about just hanging out and doing things with interesting people. Get out of your comfort zone, try something new, and make great images.

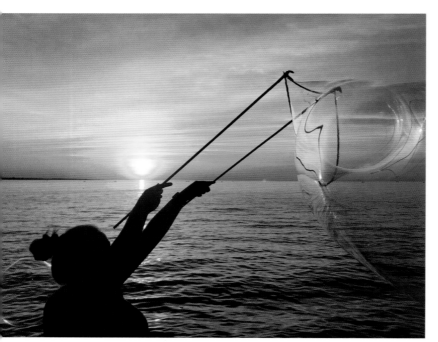

"Get out of your comfort zone. Try something new, and make great images."

Classroom

With three years of full-time teaching at a university under my belt, I am still learning about how to instruct my students more effectively and efficiently. With that caveat given, there are some things that I believe about photography, and I will continue to advocate for them.

Photography is just like any other skill set: we need to practice regularly and even do drills, because they will help us get better faster. I tell my students that improving as a photographer is like shooting free throws. It is a numbers game; the more you shoot, the better you will become.

Make images every day; if that's not doable, then strive for every week. Having the discipline to regularly make, evaluate, and edit photographs will make you a better photographer.

When students tell me that they want to become a professional photojournalist, I reach over to my office bookshelf and pull down the projects that I worked on outside of classes when I was at the Rochester Institute of Technology. I hand them to the student and

ask them if they are ready to put that kind of effort in to become better at their craft.

The reality is, it isn't easy. Yes, anyone can go out and make good images these days—the equipment really has come a long way. There is sometimes a hiccup, though, when it comes to committing to regularly making images, growing, shooting in difficult situations, and working with people, if that is part of the equation.

There are times when I feel my students want me to provide a magic formula that helps them make good images all the time. I wish that were possible. I would copyright that formula and retire so that I could travel, make more images, and tell stories. However, there is no secret sauce. So, let's work with what we have.

To make the best-possible images, you must learn to edit. You need to evaluate each frame and examine its content—what is truly there—without the influence of the feelings you had when pressing the shutter button, or a sense of nostalgia you may have for

the time or place shown in your image. On the other hand, some photographers fail to see that an image they captured is good when all of the "right parts" are there, but they don't feel an emotional connection to the shot.

In my second book, *iPhone Photography for Everybody*, there is a chapter called "Almost"—images that would have worked had I scanned the background better, lowered or raised my camera, moved left or right, or waited for a better moment to unfold—all the things that haunt an honest photographer in the middle of the night.

Time and experience have taught me that I will continue to miss images in the future, and that's okay. I think I forget the mistakes and the misses fairly quickly these days—perhaps it's age or wisdom—it is hard to separate them at times. The reality is, you miss 100 percent of the images you don't make, so let's start making them right now.

Protest

(left) During the spring semester of 2019, there were three marches in three days on campus—and one quasi counter protest. Long story short, a monument to the fallen soldiers of the South, specifically from the University of Mississippi, was erected on campus at the turn of the last century—one of three times such monuments went up. Not everyone was a fan.

The statue become a focal point on campus, and the student government recently unanimously voted to relocate it to the cemetery on campus.

In this image, H.K. Edgerton, an African-American activist for Southern heritage and a member of the Sons of Confederate Veterans, speaks to the media gathered around the statue on campus. Two groups marched from a Confederate statue on the courthouse square downtown to the campus.

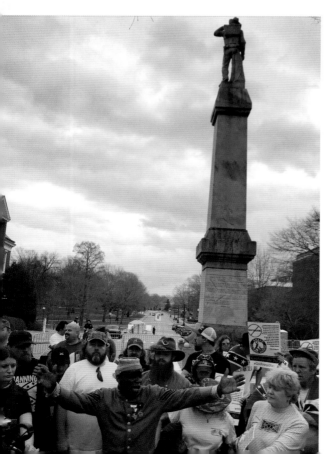

"You miss 100 percent of the images you don't make, so let's start making them right now."

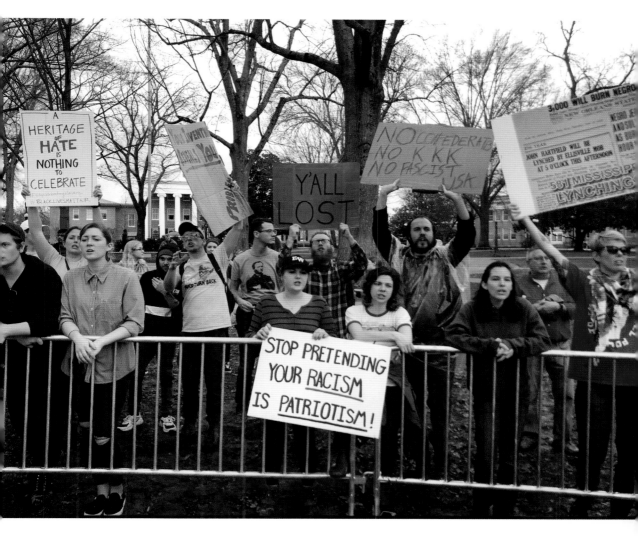

Counter Protest

(above) Counter protesters held up signs, chanted, sang, and heckled the groups that marched to the statue on campus. The university police had set up a buffer area between the two groups, and there were metal detectors at the entrances to both locations. Fortunately, the march and protest ended peacefully.

What was really remarkable was how the campus reacted, the tenor of the different marches, and how the final, main march on Saturday turned out to be anti-climactic.

From a journalism perspective, it was a fairly low-key day, though having eight students to keep tabs on, make sure they were getting the coverage they needed, and were safe, added a bit of adrenaline to the day.

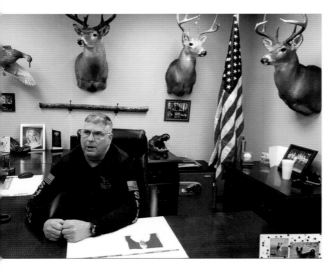

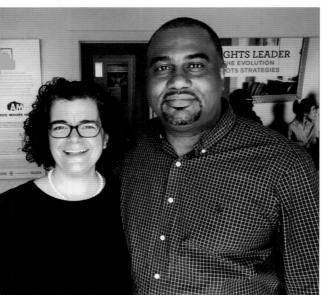

when Sheriff Jody Ashley spoke at his desk in the town of Waynesboro.

Environmental portraits like this one convey a great deal of information about the person. Sheriff Ashley had worked as a state game warden prior to being elected Sheriff, and the stories he told us about the items on display behind him told us a great deal about who he is as a resident and law enforcement officer in the state of Mississippi.

Local Heroes

(bottom) Two of my favorite people in the world—Emily Jones, university archivist, Delta State, and Will Hooker, county administrator, Bolivar County, stand in the doorway of the Amzie Moore House. Mr. Moore is a remarkable but little-known civil rights icon who made a difference in the town of Cleveland and had an impact in the Delta itself. These two patient people organized the renovation and creation of the Amzie Moore House museum so that students could learn about someone who worked in their community for decades, improving life for everyone.

Environmental Portraits

(top) Some days, the portrait finds you. I traveled to Wayne County, MS, with two other faculty members and six students to report on a trash problem that was overwhelming the county. We conducted a series of interviews. During this one, this photograph was made

In Memoriam

(top) This is my favorite image captured during a service held at Second Baptist church to dedicate a plaque in memory of Elwood Higginbotham, the seventh and last-recorded person lynched in Lafayette County. Here, Elwood's son, E. W. Higginbotham, holds the hand of my colleague, Associate Professor Vanessa Gregory, who wrote about the family in a powerful article for *New York Times* magazine. There were other important images, but this one told the story best.

Fun Run

(bottom) There was a fun run in the town of Oxford one Saturday morning. I was coming back into town from a bike ride when I found this backlit spray of water welcoming runners and walkers back to Avent Park at the conclusion of their run/walk. The two nearly silhouetted figures, mens' body language, and backlit water drops combined for a wonderful feature image that I would have been more than happy to make as a daily photojournalist. I can almost hear the sports editor asking if I have an image of the winner, like that would be more important. Tell the whole story with one image? Check.

"Strive to tell the entire story in just one image."

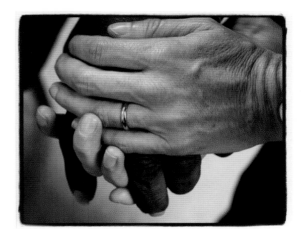

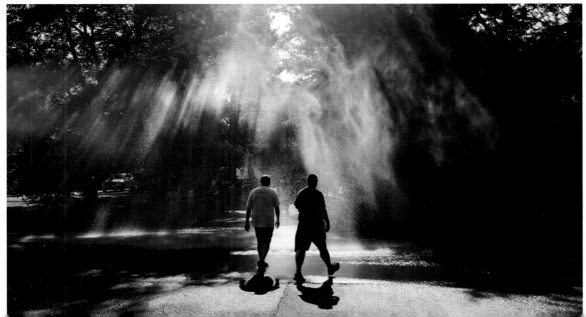

Viewing Party

(top) During my first semester on campus, there was a solar eclipse visible in Oxford. The library organized a viewing party in the quad and distributed protective eyewear, while the astronomy department pulled out the telescopes to make it a memorable afternoon. As is true for me with most news and sporting events, I was far more interested in people-watching and documenting them than in the event itself. Attendees were obviously very interested in what was happening in the sky, or what the person next to them had to say, so I wandered around the space, making candid images of the people in attendance.

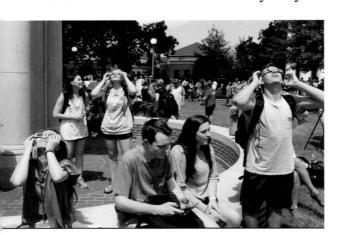

Women's March

(bottom) The city of Bakersfield occupies a unique political and social position in the state of California. Squarely in the Bible Belt of the "red" central San Joaquin Valley, Bakersfield held a women's march.

There are times when a panoramic image can start to depict the size and scale of a news event. I was careful to make this image at a place where the march slowed down as people waited to cross a narrow bridge, so there was very little blur as people were marching or moving.

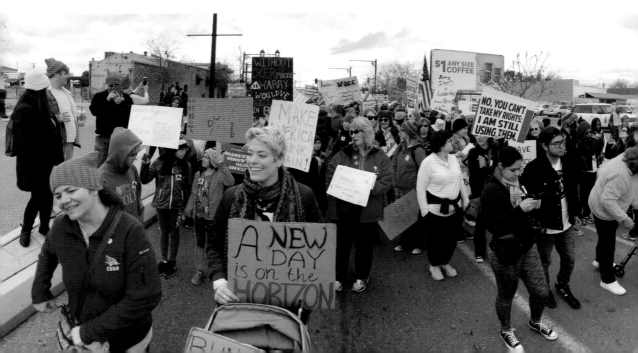

High Water

(top) I made this photo at Lake Sardis, one of the primary reservoirs in Mississippi that helps the Army Corp of Engineers control flooding in the Delta. In March, I noticed the high water while on a bike ride and stopped to record it. Little did I know what would happen.

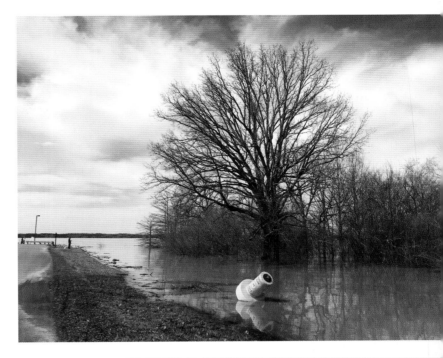

Worsening Conditions

(bottom) In April, the same parking lot was completely covered in water. Because I had captured images of the locale in March, I was able to look back and track the local impact of the Mississippi River's flooding and how the Army Corps of Engineers worked to control the flooding locally.

The flooding farther up the river in Missouri, Iowa, and Nebraska seemed to get more news coverage than it did in our state.

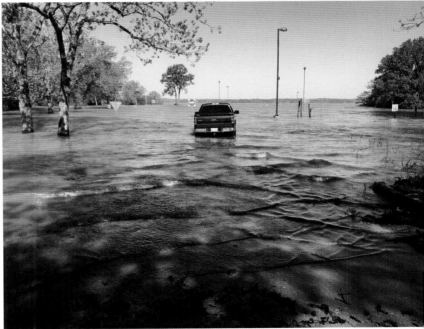

"Document the people and events happening around you."

Interview

(top) In June of 2019, I took students from my Journalism 456 class to the southern end of the Delta. Here, senior Michael Lawrence interviews a resident of Issaquena County who had been using a boat to get to his home since February until the rising water finally entered his home and flooded it in June.

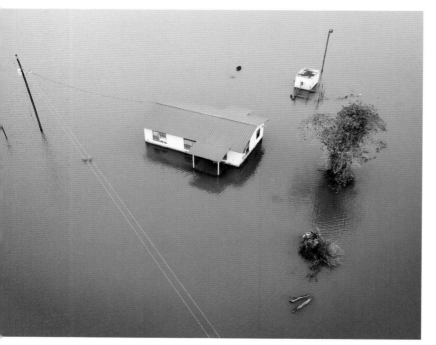

"Consider using a drone to capture important, storytelling aerial shots."

U.S. Route 61

(bottom) A lone house sits in a flooded field along U.S. Route 61 in Issaquena County. I was able to use the University's drone and capture images on my iPhone as I flew the drone over the area. While this isn't exactly an iPhone image, the final image was processed on my phone. We can let the lawyers handle the adjudication; the storytelling power of the image stands on its own.

A Sign of Normality

(top) This is one of the many small roads leading off of U.S. Route 61 that was flooded and closed to traffic. Just a little farther up the road, I could see a lone mailbox sticking out from the flood waters.

Fishing in the Fields

(bottom) Michael Lawrence and I were able to set up on the last dry parts of Mississippi Highway 465 to record the flooding. We met three men from Louisiana who were fishing in what were supposed to be fields.

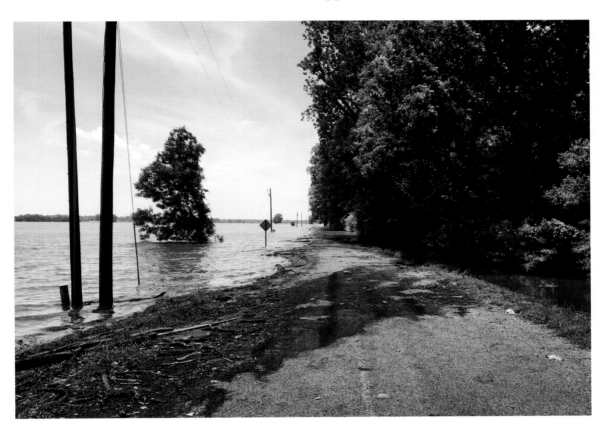

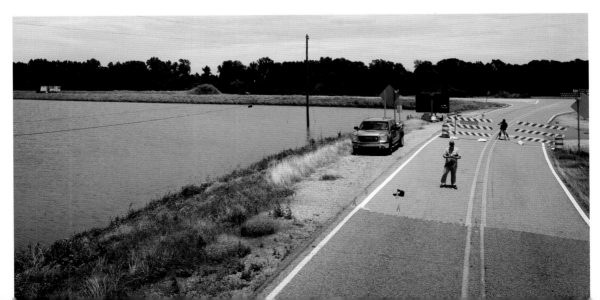

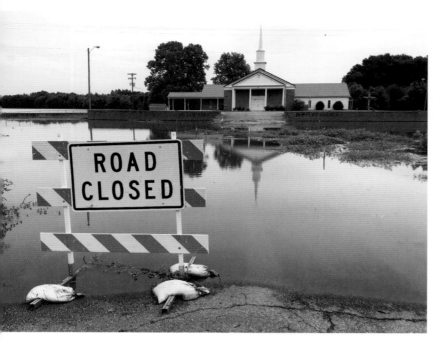

Road Closed

(top) Valley Park Baptist Church found itself surrounded by flooding; the church itself was above the flood line in June. The elevation of the unincorporated community in Issaquena County is 95 feet.

Flooded Homestead

(bottom) This home was above the flood levels; unfortunately, the road to the house was underwater, despite the sand bags. In a different month or any other year, the drive to this home would have been beautiful. Flooding events highlight the ultimate power of mother nature.

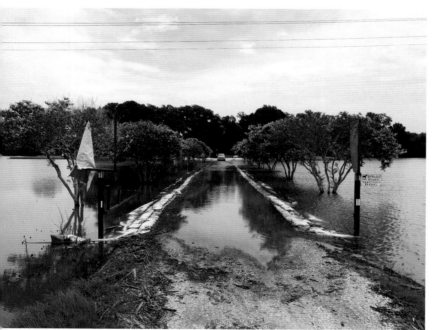

Flooded Road

(top) In June, Mississippi Highway 465 was flooded at both its northern and southern ends. The water was almost at road level, and I could see where the water had been covering the road surface.

This was one time when I felt uncomfortable. Journalists get used to moving toward things that most people have the good sense to back away from.

I made some images, flew the drone, and left in a sensible amount of time.

Rain

(bottom) One of our students, a graduate of Marjory Stoneman Douglas High School, was motivated to organize a candlelight vigil on campus. Faculty worked to make sure that things went smoothly; our Dean even handed out umbrellas. It was a learning opportunity for the organizer and her friends. The students and local media were able to cover the event. I was glad that the student felt comfortable enough to work with faculty to make this happen.

"Wipe your iPhone lens with a soft cloth when shooting in the rain."

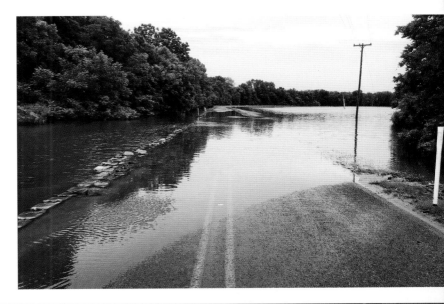

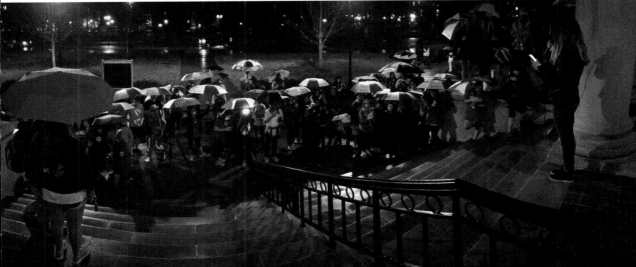

Features

Greenville, MS

(top) Greenville, MS, is an interesting town deep in the Delta. Like many parts of our country that seem to have more glorious pasts than futures, it retains glimpses of what it used to be.

I suspect that many photographers are suckers for murals, especially geometric ones that don't overpower the rest of the image. This one caught my eye.

I am a fan of finding an interesting "stage" and waiting for the actors to show up. Sometimes they do; occasionally, they do not. When I am patient and stick to what caught my eye, there is a payoff. This was a street less traveled, but I waited, and this kindly pedestrian even crossed over to my side of the street to give the image more depth.

Graphic Images

(bottom) I love graphic images, especially ones that play with our sense of perspective. When I arrived, all of these doors were closed, and the scene was not that interesting. As doors were opened and closed, the scene became more fascinating. Sometimes, timing is everything.

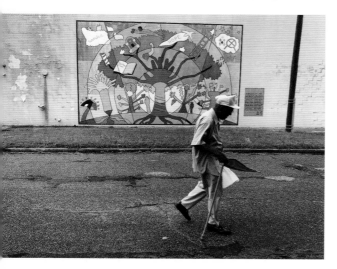

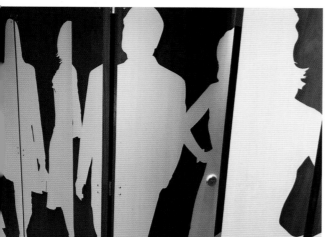

"Locate a 'stage'— something that makes a great background— and wait for the actors to show up."

Framing Devices

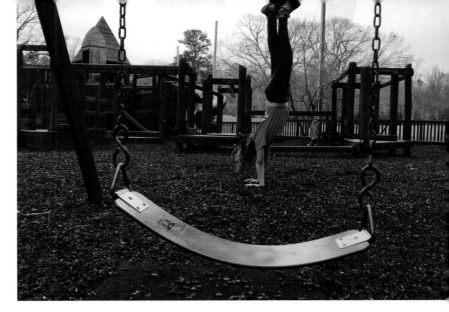

(top) Find and use framing devices in a scene to make more powerful photographs.

A pop of color can also draw the eye to an area of interest. Rumor has it that *National Geographic* photographers used to carry red sweaters with them back in the days of Koda-chrome. Perhaps that is a tale from the golden age of photography, but the spot color in this image certainly helps my two children stand out amidst the drab surroundings. The handstand doesn't hurt, either.

Composition

(bottom) I am a sucker for grids, repeating shapes, and graphics. I have worked with designers and have learned the power of laying objects out in a clear way that allows us to easily explore them.

Radio Social is a bowling alley, restaurant, bar, music venue, and social club in Rochester, NY. Our group from the Kalish Photo Editing Workshop had a great time there, and many of us made interesting frames during this outing.

On the Shores

(top) My wife grew up on the shores of Lake Michigan. I once interned at *The Muskegon Chronicle*, so I understand why the Great Lakes still hold the heart of my beloved. Whenever we visit, we have to spend time at the lake. Fortunately, for me, that means time for

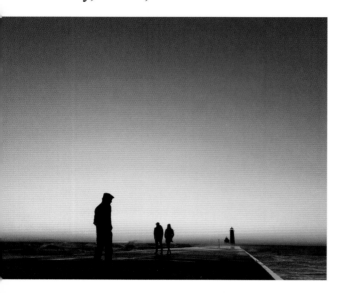

photography and adventures for the kiddos.

I like that the lighthouse—a subject featured in many photographs—is not the focal point of this image.

A Gust of Wind

(bottom) This sunset image was made on a cold and windy day. The chilled air gusted and made it difficult to stand at times. I love the view of this woman leaning into the wind to make her image. Her posture underscores the weather conditions on that day.

I get cold just looking at these photos, but the power and the beauty of Lake Michigan, especially in winter, is captivating.

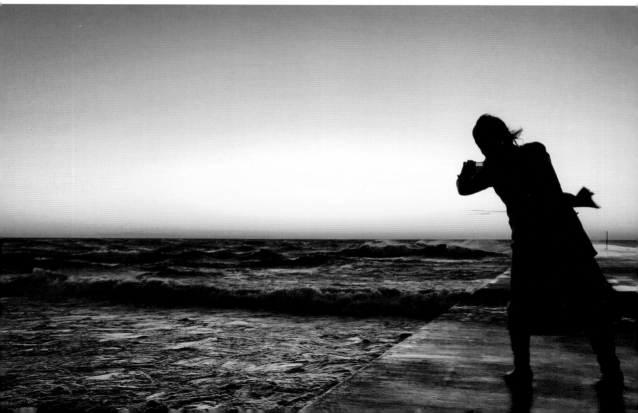

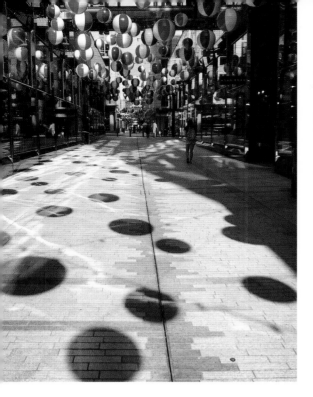

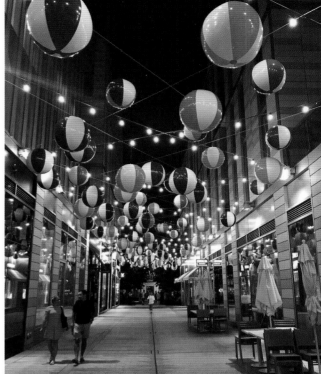

Spectacular Shadows

(left) Visit places multiple times and at different times of day to make images. It will pay off. Trust me.

Here are two shots from a multi-zoned space in Washington, D.C., where apartment buildings had restaurants and stores and lovely spaces connecting them. Capturing shots at various times of day will show you that as the light changes, the scenes will, too. Shadows are the main focus in the first image.

"Make repeat visits to the same location and photograph it. Shoot at different times of day."

City at Night

(right) At night, the same location shown in the first image is almost a different place. I really like the way the two images have different moods and evoke a different emotional reaction in viewers.

Sometimes photographers get stuck making images only during "golden hour"—the hour after sunrise and hour before sunset, when the light is warm and comes from a low angle. The truth is, good and interesting images can be made at any time of day.

Visiting a place multiple times can help us better see and photograph it. Yes, this is a luxury at times, but it's a practice that is well worth the effort.

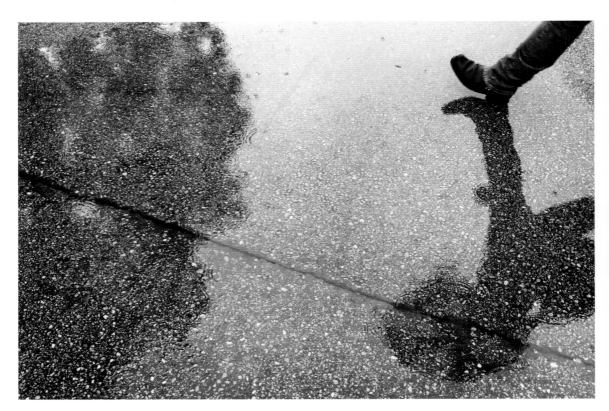

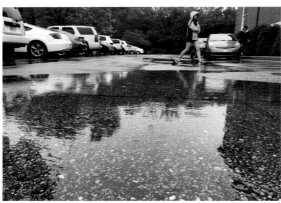

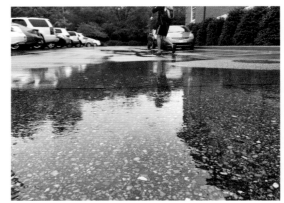

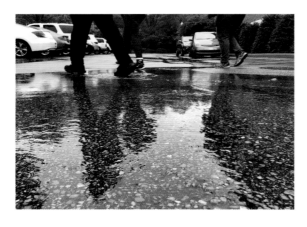

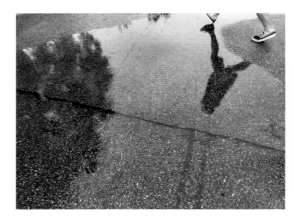

Finding Opportunities

(previous page) One day, a student was struggling with my feature photo assignment. I suggested that we step outside of my office and see what we could find. Just ten yards out of Farley Hall, we found this puddle, and I began to explore the moment. Different perspectives and levels started to yield more interesting photographs, and then the right composition and moment came into being. These images are shown in the order in which they were made.

Too often, people look at images and say, "Yup, that works." They don't see the images made before the "right" one and do not always edit to separate the wheat from the chaff.

Street Photography

(top) In a perfect world, I would have worked this image more. The reality of street photography, however, is that you only get fleeting moments to nail the shot. Sometimes you get it right, sometimes not.

I like the strong silhouette and blurred action of the passing subway car, but I am not content with the framing. I still like the image enough to include it in this book.

Siblings

(bottom) Feature photos are everywhere we look. I like the graphic design of this image and the comparison of the two kids (yes, they are mine). My son looks up to, chases, and tries to be like his big sister. Yet, there are times when she lets him catch her and magical moments when they appreciate each other and the way they fit into the world.

"Capture actions or expressions that define the relationship between your subjects."

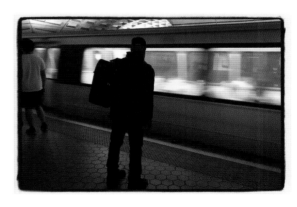

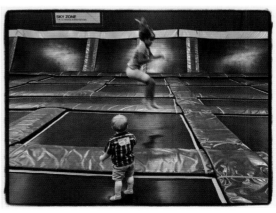

Food

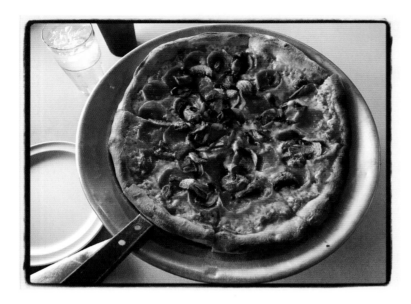

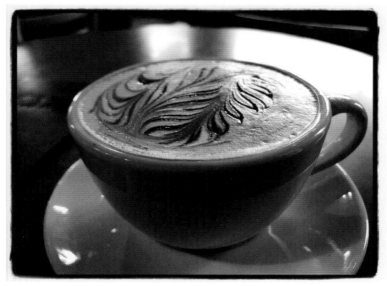

Pizza

(top) Those who know me will vouch that I *really* like pizza. I have multiple books and techniques for making dough and "throwing pies," and I seek out the best pizza wherever I live or visit. TriBecca Allie Cafe in Sardis does some amazing work, and the owner/chef has traveled to and competed in Italy. Family brought him to Mississippi, and I am thankful.

Java

(bottom) Food photography can be a matter of perspective, seeing how the light falls, and sometimes telling a story.

Strong images can make you crave whatever is in the image.

"Take some food photos during your next restaurant visit."

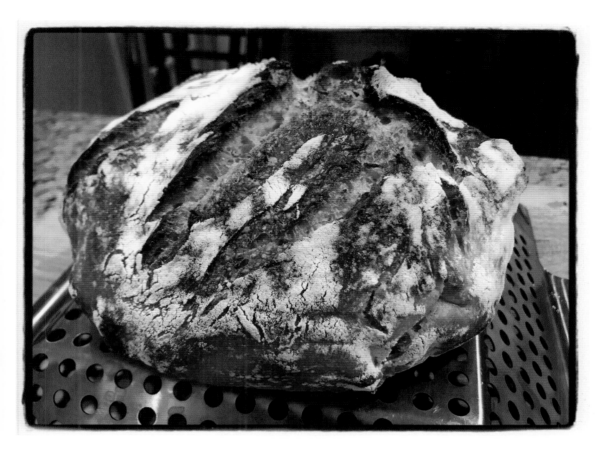

Bread

(above) I got the bread-making bug from my father and brother. The process is mostly about allowing yeast to do its thing. Words cannot describe the scent of fresh bread or the feeling you get when you bite into a buttery slice.

Babka

(bottom) When I get a taste for something and can't find it locally, I make it at home. This was my first go at making chocolate babka. If you've never tried it, get yourself to a good bakery. If you're one who likes to bake, give the

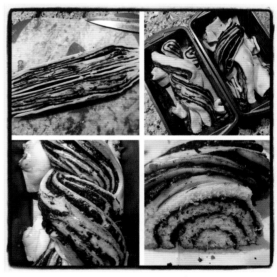

process a whirl. It can be a bit messy to make, but the bittersweet chocolate and slightly sweet dough are sinful.

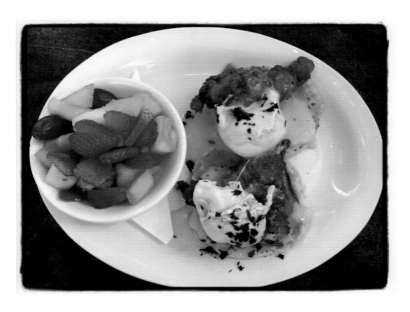

probably the only meal you need for the day if you eat it for lunch. If you ever visit Oxford, be sure to head to Big Bad Breakfast. I cannot say enough about the combination offered in the pictured dish. It is well worth your time to try it.

Tarasque Cucina

(bottom) If I have a John Currence food image, I had better have a John Stokes plate, too. John and his wife Lauren run Tarasque Cucina in Oxford. I may be biased in loving this image because this was my birthday meal, but good photography should make you want to eat the meal. The silverware adds depth to the photo and brings your eye to the spicy and creamy shrimp linguini. The hospitality that this couple provides every customer is unparalleled.

"A white dinner plate puts the focus on the food in your image."

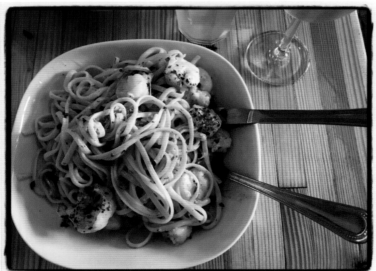

Big Bad Breakfast

(top) Big Bad Breakfast in Oxford is the child of Chef John Currence, the recipient of the James Beard Award for Best Chef South in 2009. One of my favorite "off menu" items is the eggs Benedict; at this eatery, fried chicken is substituted for the usual ham. This is

A Family Tradition

(top) In my family, it is a tradition to have sticky buns for breakfast on Christmas Day. My parents used to get the good old Pillsbury rolls in the cardboard tube that would pop when you twisted it open. These days, two brothers make homemade versions and one sticks with the Pillsbury variety. No matter the approach, children and adults can't wait for the rolls to cool down, and most folks usually consume more than enough as the day progresses.

The simplicity and graphic quality of this photograph appeals to me.

The homemade rolls have a little more personality. You can tell they are hand made, and you can see the love. I am curious to see if our Christmas breakfast tradition gets passed down to our children. I hope so. Food is attached to memories in our lives.

Gooey Goodness

(bottom) A change in perspective between these two shots highlights the story you can tell with food.

Depending upon what stage we are at, these are either the tops or bottoms of the buns. You can see the stickiness on the pan.

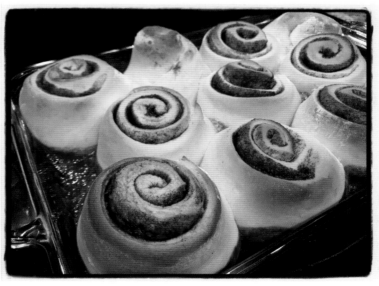

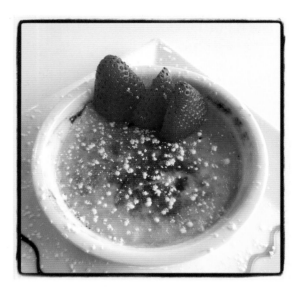

Creme Brûlée? Hooray!

(top) Who doesn't enjoy creme brûlée? I like the way the circular bowl plays off the square plate beneath it. The strawberry slices and caramelized sugar break up the symmetry of the image, and the squiggles on the bottom corners of the plate help to frame the subject. I must confess: my mouth is watering as I type.

Break the Rules

(bottom) Photographic rules like "Don't shoot into the sun" should be broken from time to time. Don't hesitate to use backlight to highlight beverages and glassware.

This is cava in a Mason jar—my Mississippi in beverage form. We had just moved to Oxford, and to celebrate, I was enjoying a libation despite the fact that we'd not unpacked our glassware yet. I like the combination of low brow and high brow so much that I've used Mason jars for subsequent parties, even after we unpacked the glasses.

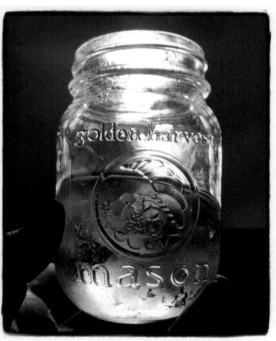

"Break photographic rules like 'don't shoot into the sun' from time to time."

Portraits

Environmental Portrait

(top) Alexe van Beuren stands proudly behind the counter at the B.T.C. Grocery in Water Valley. I visited the town with a group of photographers from the university's yearbook staff to team-build and make some images. While I was waiting for my students, I wandered into the store, saw the beautiful directional light and the artwork behind Alexe, and asked her if I could make a portrait.

Zany Professor?

(bottom) Curt Chandler is a talented and friendly professor with Penn State's Donald B. Pellisario College of Communication and is also a former newspaper journalist. He has a good poker face and a great sense of humor. We were in the midst of helping students edit their Lens Collective video projects when I captured this portrait.

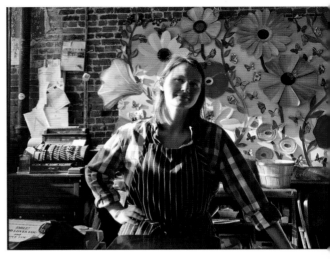

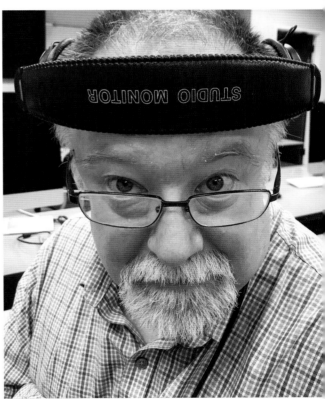

Fashion Forward

(top) I photographed Ariel Cobbert at the Double Decker Festival in Oxford, MS. Ariel is one of the more talented photojournalists I have worked with at the University of Mississippi. Professors can be accused of favoritism, but when students go out and do the work, listen to critiques and respond positively to them, and have a glowing personality, it is easy to like them.

Ariel's fashion work is impressive. I look forward to seeing where her artistic eye and positive attitude take her.

Culinary Coverage

(bottom) Corbin Evans is the chef and owner at the New Oxford Canteen. The smile on his face is matched only by the food that he serves up.

The New Oxford Canteen was a gas station in a past life. You should never judge a restaurant in our county by how it looks on the outside. That is probably true of many other things in life, too.

There is a strong and innovative food scene in Oxford, and Corbin fits right in.

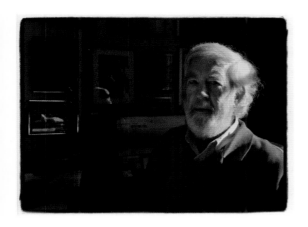

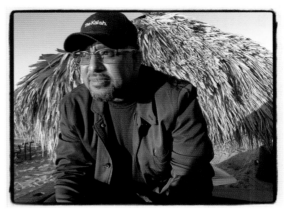

Journalism Legend

(left) Curtis Wilkie is a Mississippi journalism institution legend and an Overby Fellow. I had the good fortune to drive to a conference with Curtis, and our conversations were illuminating, funny, and wide ranging.

What makes this portrait work for me is how the window light is falling on Curtis and the contrast between his hair and the wall.

In a fast-paced world, it is a pleasure to have a thoughtful and plainspoken colleague like Curtis. At the conference he spoke at, he observed that his comments might be perceived as the ants attending a picnic, and then proceeded to offer an insightful view of the Mississippi narrative.

A Mentor

(right) If you don't have a mentor in life, go out and find one. Kenny Irby has been my career-long mentor and ethicist. He never hesitates to call me on my language use and inspires me to be a better photojournalist. I have had the opportunity to preach at his church after I managed to "get all up in his sermon" on a prior visit.

Kenny was a faculty member at the Kalish Editing Workshop, and I continued to learn from him that summer. We also had a good conversation as we watched the sun set over Lake Ontario.

Your mentor doesn't have to be older than you; one of my former students from an adult continuing education class still checks in with me from time to time.

"Find a mentor who can help you progress your photographic skills."

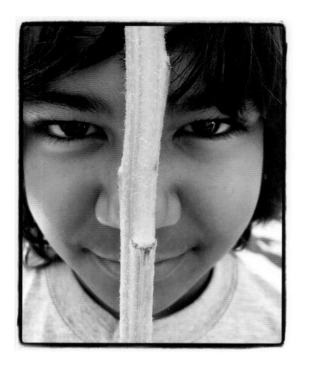

Symmetry

(top) Our daughter captured my heart on the day we first met. I have been making photographs of her for some time now. Trying to capture the myriad aspects of who she is and is becoming seems a fool's errand at times.

I love how the sunflower stem bisects this image and draws attention to her eyes. The stem also divides her face and causes the viewer to compare one side to the other. There is a catchlight (a reflection of the light source in the iris that causes the eyes to seem to sparkle) in her left eye, created by the daylight spilling under the flower vendor's tent.

Frozen in Time

(bottom) Here's my daughter again. She loves to explore the world (well, she did before she entered her tweens). This image was made when she found some ice at Oma and Opa's house in Michigan. The distortion of the ice contrasts with her in-focus fingers and causes the eye to linger on her face and hat as the image is viewed. Also interesting is the fact that one crack runs through her left eye, while I can just make out her right eye.

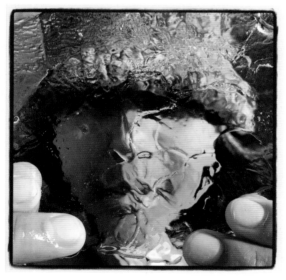

"Photograph those you love every chance you get. Create magical memories."

Two Favorites

(top) Here are two of my favorite journalists in the state of Mississippi. My colleague, Alysia Burton Steele, and Jerry Mitchell, who founded the Mississippi Center for Investigative Reporting, are two fantastic human beings as well as great journalists. Jerry's reporting continues to shed light into areas that many folks don't want people looking into. Alysia's first book, *Delta Jewels*, is an amazing oral history and portraiture series of "Ordinary women [who] lived extraordinary lives under the harshest conditions of the Jim Crow era and during the courageous changes of the Civil Rights Movement." Look out world! Both are still reporting.

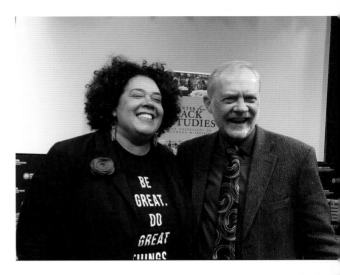

Free Hugs

(bottom) I met this young man my first semester on campus and did indeed collect my free hug. We did not have a long conversation because I was on my way to the student media center, but a student in one of my classes interviewed him for an audio assignment, and his story was an impressive and touching one. Offering hugs and positive affirmation is one of the ways that this remarkable man leads his life.

Take a moment out of your day, collect a hug, make a portrait, and let the positive ripples radiate out.

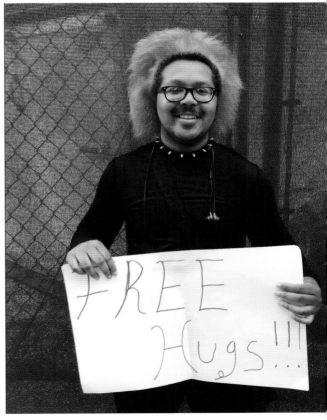

Ten Tips

1. Be curious, be patient.
2. Keep it simple, stupid (KISS).
3. Look for the good light.
4. Use the Rule of Thirds. Imagine that there is a tic-tac-toe grid superimposed over the scene. Position the horizon, if there is one in the scene, at the top or bottom horizontal line. If there is a person in the frame, try to position their eyes on the upper line. For a strong composition, also try to place the main subject at one of the points at which the horizontal and vertical lines intersect. The Rule of Thirds is your friend.
5. Activate the Rule of Thirds grid on your iPhone. This will aid you in perfecting the placement of the subject.
6. Using framing devices.
7. Utilize leading lines and graphics.
8. Seek out symmetry and patterns.
9. Look for ways to create depth in the image. Include foreground, middle ground, and background elements in the frame.
10. Let people be themselves.

"Include foreground, middle ground, and background elements in the frame."

Mississippi

When my wife and I announced that we would be relocating to Mississippi, we were met with a number of similar reactions. People were happy to learn that I would be teaching at the School of Journalism, but the next question was inevitably a variation of, *"Why Mississippi?"*

I spent a number of my formative years in some of the farming communities of Southern New Jersey. If you look carefully at a map, I did technically spend those years south of the Mason–Dixon line. This is a long-winded way of saying that I don't necessarily feel out of place in Mississippi, although I am still introduced as "the professor from California" from time to time. There is much to like about Mississippi. I have no problem with hard workers, farmers, agriculture, an eclectic music culture, the academy, good food, and even tricky social situations.

It is always interesting to run into students or recent graduates while off campus. I think at times folks forget that professors are real people who do things outside the classroom or office.

However, I do enjoy the double-take I get from time to time. I am glad when graduates I encounter in the "outside world" are comfortable enough to give me a hug or shake my hand. I am often hard on my students, and graduates may hold that memory of me—but I demand good work because I want my students to be good, professional journalists.

So, yes; I made a home in Mississippi. I will leave the last words to the literary father of Oxford, William Faulkner: "To understand the world, you must first understand a place like Mississippi."

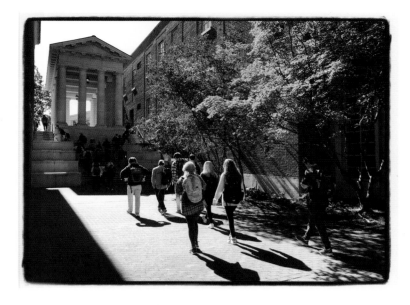

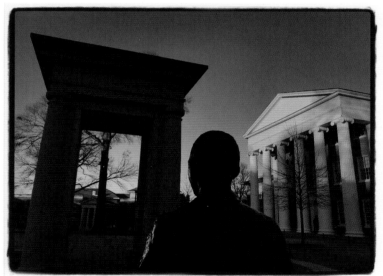

than the well-maintained grounds, you can start to see the care applied all around campus.

You are probably getting tired of me pointing out the effectiveness of strong, diagonal light in images, but "look for the right light" is advice worth repeating. Lighting can make or break an image.

The foreground in this image and columns in the background help to establish a sense of depth in the photograph.

History Lesson

(bottom) Here is a statue of James Meredith, who integrated the University of Mississippi in 1962. Also shown is the Lyceum, currently the administration building, which was built in the Greek Revival style and was the first building constructed on campus.

Riots that accompanied James Meredith's attendance were recorded for all time in front of the Lyceum.

Architecture and Light

(top) The University of Mississippi campus is considered one of the most beautiful in the country. While this image is more about architecture and light

"Look to include strong directional lighting in your images."

The Grove

(top) In early morning on graduation day, staff members wiped down every one of the chairs set up in the Grove for the commencement ceremony. The Grove is at the heart of campus and is immaculately maintained. I have been talked into taking classes out there on a many a nice spring afternoon. It's not a heavy lift at all.

and far reaching. The university is having a conversation that much of our country also needs to have.

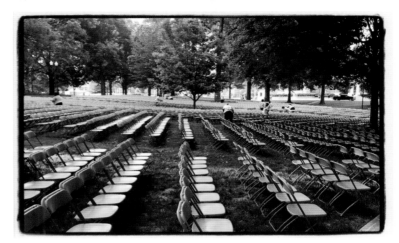

Dappled Light

(bottom) In front of the circle before the Lyceum, on the same axis as the administration building and library, stands a statue that comemorates the Confederate fallen. In the early-evening winter light, the statue and Ventress Hall simply glow.

As the student body, faculty, administration, and the Institutions of Higher Learning board consider the way forward, the shadow cast over the campus is long

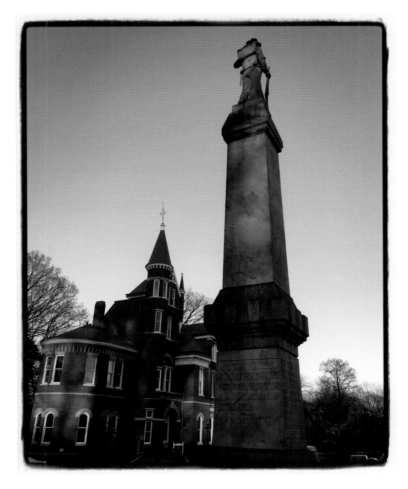

Lens Collective

(top) Students from multiple universities watch a video on the first night of the Lens Collective. Visual journalists from American University, Arkansas State University, Jackson State University, Middle Tennessee State University, Ohio University, Penn State University, the University of Mississippi, and West Virginia University gathered to work with 15 faculty members and document the culture of the Mississippi Delta. It was great to see students forming friendships on the first night. Kudos to my colleague Alysia Burton Steele for organizing and running the collective.

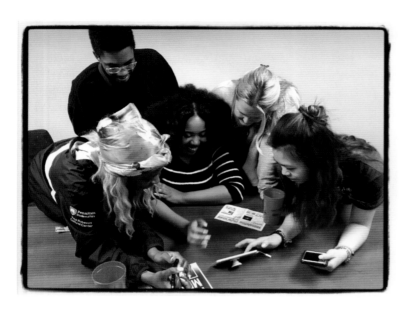

Throw Down

(bottom) A little bit of old technology photo editing in my classroom—I call this the paper "throw down." Students are given black & white printouts of a former student's story and asked to edit together a photo essay. I like using black & white images because there is no color information to overwhelm the content of the images.

When the task is complete, I post the different versions of groups' edits and talk about how to tell a story with images. After we arrive at some possible story lines, I give the students color images to work with.

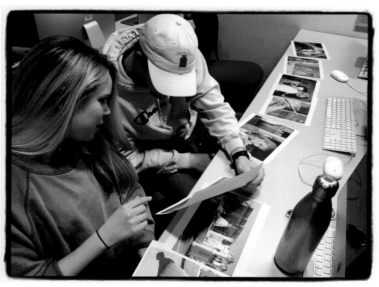

Story Box

(top) Another in-class assignment. I had my students use a children's story box—a kit that contains various cards containing discrete parts of a story—to lay out and tell a story of their own. I like this exercise, because the story box contains everything you need to create two fairy tales, and you can put them together however you like.

After the students edit their story, I have one person from each group tell the story to the rest of the class. Most stories follow a linear format. I ask my students why they arranged the story elements to tell a chronological story. I want them to consider that the tendency points to the fact that we are sometimes handcuffed by format.

My students reported that they liked this hands-on group exercise.

How Low Can You Go?

(bottom) A student lies down in the grass alongside a road in Wayne County to include some trash in the image he is composing. I appreciate that the student committed to their storytelling craft in this manner.

This photograph makes me think of Andrew Wyeth's painting, *Christina's World*. The student is in the same pose, although he is flipped horizontally. Anytime I am able to create an image

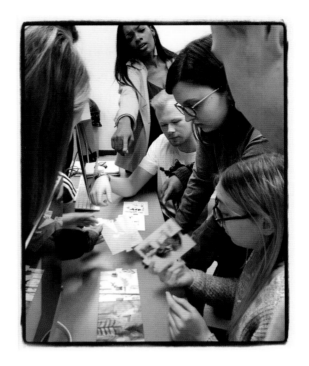

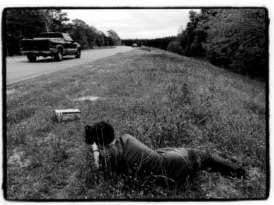

"Study classic works of art to gain inspiration for your photography."

that refers to another work of art, I rejoice.

At the Crossroads

(top) This is me standing at the "real" crossroads of blues music history and folklore. The intersection is near Dockery Farms, a former cotton plantation in the Delta where "father of the Delta blues," the legendary Charley (Charlie) Patton, intermittently lived and performed. As with almost all things Mississippi, it is complicated. Dockery "was essentially a self-sufficient town with an elementary school, churches,

"Make history. Capture historic locales in your town."

post and telegraph offices, its own currency, resident doctor, railroad depot, ferry, blacksmith shop, cotton gin, cemeteries, picnic grounds for the workers, and a commissary that sold dry goods, furniture, and groceries" (https://www .hmdb.org/m.asp?m=104690).

Teamwork

(bottom) Crunch time on a Lens Collective edit. I like the range of emotions on display as this group works on their video.

There are many different things the workshop helps students learn: respectfully and honestly documenting in the Delta, working as a team, hitting deadline, and telling a story. While there are no grades attached, at least for our students, journalists still want to do a good job and tell a story accurately and well. That in and of itself brings its own pressures.

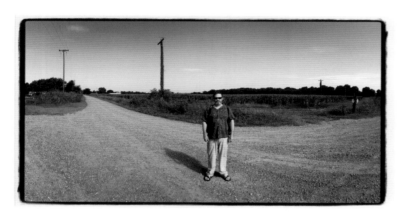

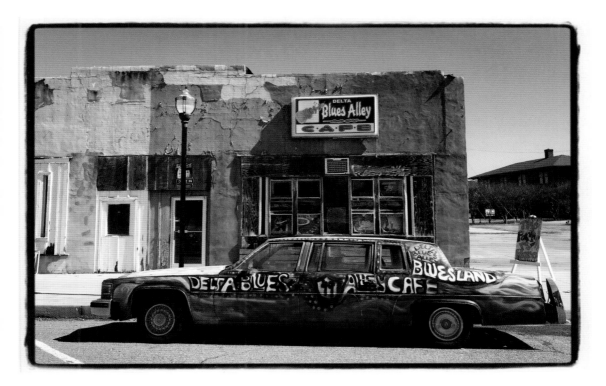

Blues Mobile

(top) As you can see in this photo, the Delta Blues Alley Cafe has a very colorful way of advertising in Clarksdale. The town has a rich history; it played an important role in the Civil Rights movement and has a rich American blues heritage. The Delta Blues Museum, Ground Zero, and the Juke Joint Festival help keep the blues resonating through the town. An Aaron Henry and Civil Rights Movement museum is currently in the works, at a Delta pace.

Dockery Door

(bottom) This is a door in a building next to the cotton gin on Dockery Farm. The plantation farmed thousands of

acres along the Sunflower River. At its peak, there were 400 tenant farmers' families living and working on it. Part of the farm still exists today. There is a self-guided tour when it is open. The site includes a unique gas-station-turned-exhibition space, too.

Ghosts

(top) Throughout the Delta, there are ghosts, relics of what used to exist. Here is all that remains of a gas station now in the corner of a field between Cleveland and Clarksdale.

Photographers seem to love images that suggest the passage of time. It is likely because our art form isolates moments in time and preserves them. I am sure that we all have images of rusty objects, old buildings, and other things that show the impact of time.

Magnolia

(bottom) A magnolia tree flower in bloom. If it were just a blossom on the state tree, it might be unremarkable. However, this tree grows near what remains of Bryant's Grocery and Meat Market in Money, MS. This infamous location is where Emmett Till encountered Carolyn Bryant. What exactly happened is open to some interpretation, but the end result is not. Emmett's beaten body was found tied to a 75-pound cotton-gin fan in the Tallahatchie River. His death and the subsequent trial brought to light the reality of the Jim Crow South. Many historians argue that this case was an early impetus of the Civil Rights Movement.

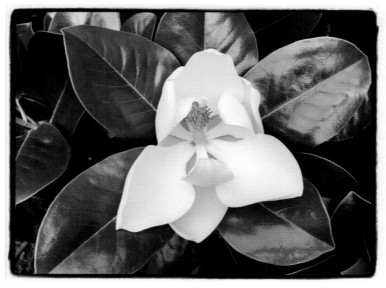

Juke Joint

(top) Po' Monkey's was one of the last juke joints in the Mississippi Delta. Anthony Bourdain filmed a *Parts Unknown* segment there. Sadly, Willie Seaberry, the heart and soul of the joint, passed away, and with him a 50-year tradition. Last I heard, the building is still standing. To try to explain what Po' Monkey's was like is a tall order. I would suggest trying to find Bourdain's Mississippi episode for a more accurate picture than I can paint with words.

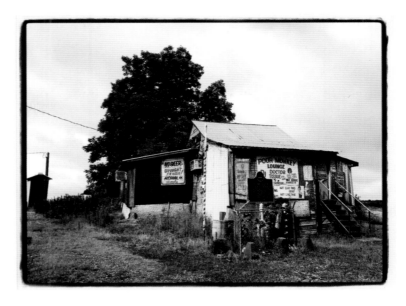

Aaron Henry

(bottom) Sometimes you just have to stand in a field and make an image. Yes, that is me. Clarksdale has done a nice job of marking historically significant places around town with these silhouettes. Aaron Henry was a WWII veteran who returned to Mississippi and ran head-on into the poll tax. He was a founding member of the Regional Council of Negro Leadership, and he and Amzie Moore helped distribute thousands of bumper stickers that read, "Don't buy gas where you can't use the restroom."

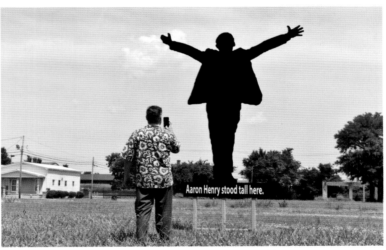

Aaron Henry stood tall here.

"Try a black & white treatment for photos of historic places."

Shotgun

(top) Welcome to the east side of Cleveland, MS. I would argue that this is not even a full "shotgun" house. I like the single chair in front of the home.

I found this tableau as the team I was coaching was working on the Amzie Moore story. Mr. Moore's gas station used to be located across the street from this house. It is no longer a gas station; one of his sons tried to turn it into a biker bar at one point.

Delta Flood

(bottom) Flooding is a way of life in the Delta. In 2019, we saw flooding in the southern end of the Delta that came close to the devastating Great Flood of 1927. This is Big Creek, overflowing its banks in the spring. Yes, that is a church in the background. The water ultimately reached the front steps of the structure, but never entered. A series of reservoirs in the central part of the state help the Army Corps of Engineers keep the flooding in the Delta under control—as much as humans can. I owe much of what I know about Mississippi's history to my colleagues and the guests who come to campus. My immersion in the state's culture came as I helped document The Most Southern Place on Earth workshop held at Delta State University. Dr. Rolando Herts and Lee Aylward can really tell a good story.

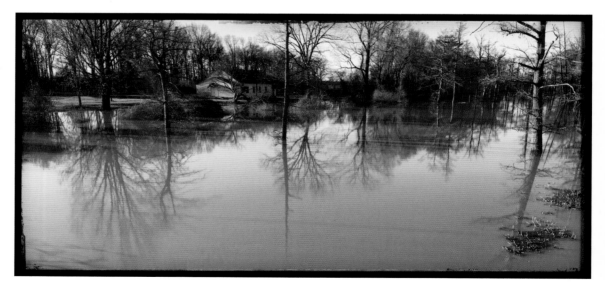

Get Lost!

(top) One of the things I learned as a daily newspaper photojournalist was that it is important to go out and intentionally get lost. I can't really tell you where we were when I made this photo. In looking at the contact sheet and photo files on either side of this one, I'd say I was probably in Wayne County, MS—but that is as confident as I can be. The beauty of getting lost on purpose is that you find things that you didn't know were out there. All too often in life we know where we are going and what we expect to happen there. Stumbling across new places and new things helps me see the world a little differently.

All Hail the King

(bottom) All sorts of things happened in Clarksdale. I really like how this Elvis silhouette, which appears blue, plays against the well-lit Civic Auditorium. I liked the words "the King was in the building" at the bottom, but I felt that they were a distraction in the image and decided to exclude them when I composed the shot. When you include words in your images, your viewers will try to read them and will not be as focused on the other elements in the frame.

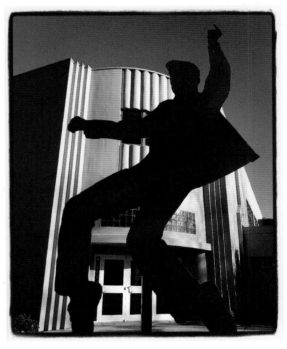

"Wander. Get lost on purpose. Let the scenes that you encounter inspire you."

Memorial

(top) Yes, that is indeed what you think it is: the Lorraine Motel in Memphis, which now houses the National Civil Rights Museum. The wreath was placed in 2018 to commemorate the 50th anniversary of the assassination of Dr. Martin Luther King. The museum is worth your time to visit. Be sure to set aside a significant amount of time to spend there. You will need it.

A Place in the Sun

(bottom) It is an interesting time to be living, teaching, and working in the state of Mississippi. There is much to be encouraged about seeing. On the other hand, there are things you encounter that feel like steps sideways, or no action at all. I hope at the very least that you got a glimpse of the amazing people and potential I see all around the state. I am most impressed by our students, who continue to practice their craft, and our alums, who have made contributions in the field. As the sun lights up the American flag flying over campus, I hope that we are seeing a sunrise in our state.

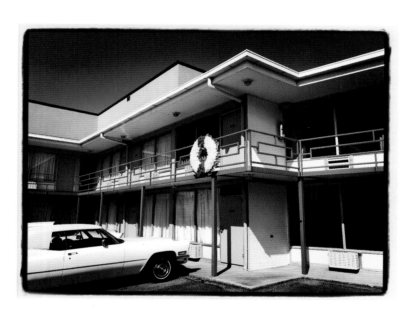

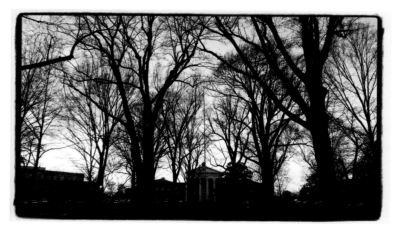

Turtle's Pace

(top) I have seen many more turtles this year than last. Last year, I encountered plenty of armadillos—sadly, I usually spotted them on the side of the road, post-accident. The turtles seem to be weathering the roads in Mississippi better than the armadillos did.

This little guy was sunning himself outside Oxford proper, and I helped him safely off the road before I continued my bike ride.

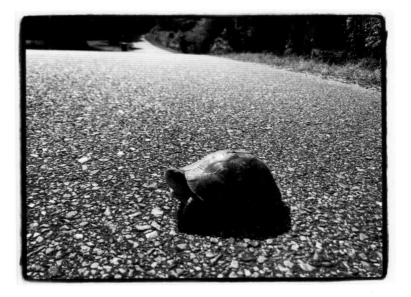

Mimosa

(bottom) My friends on Facebook quickly helped me identify the mimosa tree, Albizia julibrissin, which is invasive in the wetter parts of the country. I spotted this specimen alongside the road south of Taylor. A small shaft of light illuminated this particular branch.

This was one of the times I should have put my phone away and enjoyed the moment. Sadly, the image does not do the stunning mimosa justice.

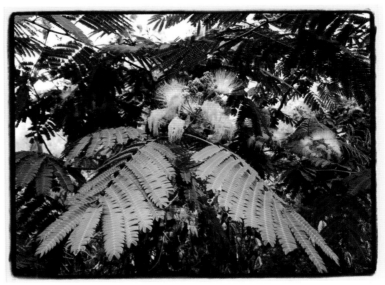

"Take time to appreciate the beauty around you once you have taken your photos."

Overcast Days

(top) My walks with our son inevitably wind up with one of us getting distracted by something—or each other. Here, a beautiful zinnia greeted us on a rainy and cloudy day.

On an overcast day, the clouds diffuse the sunlight, making for soft lighting that works to the photographer's advantage.

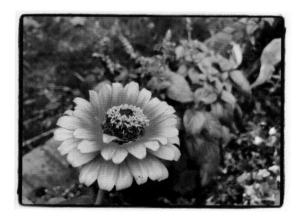

The strong diagonal of the brick wall keeps the eye moving through the frame.

Lyceum

(bottom) I worked this image for a while. I was trying to catch students walking past the Lyceum, the current administration building on campus.

I like that the large tree on the left breaks the symmetry of the building. Bill DuBois at RIT would probably chastise me for not having the right side of the building in the frame. I miss those 4x5 film days, but it really had a way of slowing a photographer down. Of course, being slow and deliberate and really thinking about the shots you take is a good thing for certain kinds of photography.

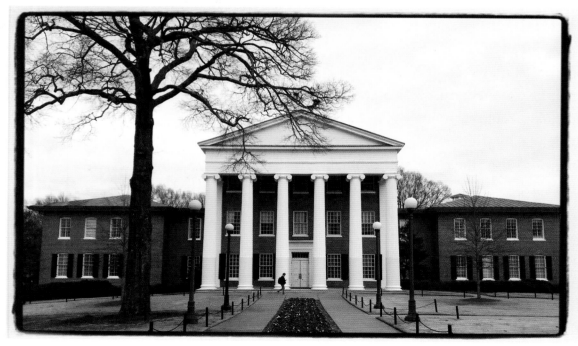

First Impressions

(top) I made this photograph during one of my first weeks at Farley Hall and the University of Mississippi. As is the case in most scenarios when I am photographing an area that contains lots of people, what interested me was the individual students and what they were doing. Here, the students were waiting to enter the largest lecture room on the second floor.

The light came from multiple windows as well as from overhead and provided a good, even exposure.

I can't recall where I was going when I took this photo, but I am sure I went the opposite way after I had made some images.

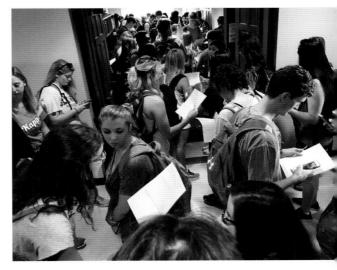

Square Books

We are fortunate to have one of the best independent book stores in downtown Oxford. This wonderful business is called Square Books. Not content to do anything halfway, there is also a shop called Off-Square Books in another building, and Square Books Jr. on another side of the square.

I am always looking for different perspectives, and certainly, shooting from a higher altitude in this case allowed me to give the viewer a better sense of the depth of the store in this image.

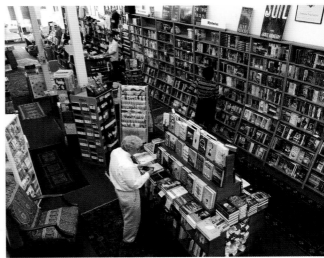

"Capture a scene from a variety of perspectives, then determine which one works best."

Nostalgia

(top) The Airport Grocery is one of those places you kind of expect to see in the Delta. It's a good place to eat, and the decor—especially on the front porch—begs to be photographed. Throw in strong afternoon light and some shadows, and like me, you may find yourself late for your meal.

I really tried to shy away from the strong graphics and words on the signs and cooler, but doing so proved difficult in this situation.

Cloud Formations

(bottom) In Mississippi, we may not have the mountains of the West, but we do get towering cloud formations and beautiful sunsets. This photo could have easily gone in the first chapter because this is a half-mile walk from our house. However, it is distinctly Mississippi, too.

The reflections of the sky on the cars and lights in the restaurant help keep the eye from moving up into the sky and staying there.

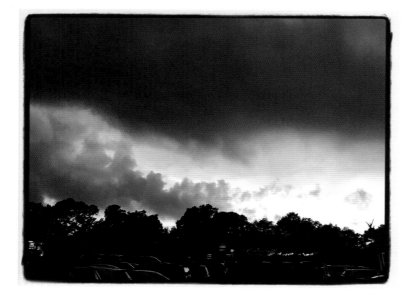

Burning Leaves

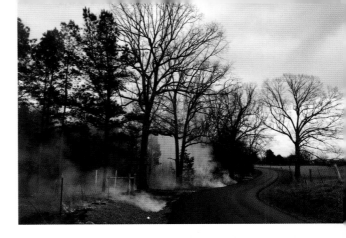

(top) The burning off of autumn leaves. I came across this scene while I was on a bicycle ride on the northwest side of town. Apparently, this is a "southern thing"; a friend who lived in Arkansas told me that he regularly saw leaf burnings in the spring.

I made some images in which the flames and fence looked better, but I like that, in this version, the road and the smoke move your eye through the frame. I also like the relationship between the large tree in the center and the smaller one on the right side of the frame.

Cotton Gin

(bottom) One of the engines that "drove" the Delta was cotton. This is the cotton gin on Dockery Farms, which, at its peak, was a 25,600-acre cotton plantation and sawmill. As mentioned earlier in the book, Dockery Farms is also widely regarded as the place at which the Delta blues was born. If you're interested in music in general or blues history in particular, look up Charley Patton and Robert Johnson.

"Capture close-ups or detail shots to add variety to your image portfolio."

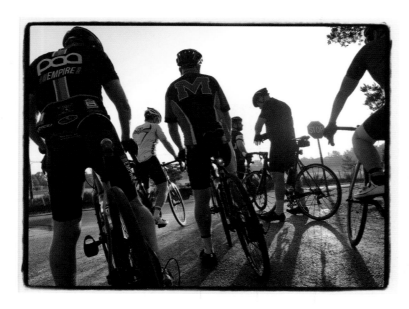

Too Much Sun?

(top) This photo opportunity presented itself during a short break on a morning group ride out of Oxford.

When shooting into the sun, I typically try to hide it behind something or someone to prevent lens flare—though there are times that I like the lens effects you can get when shooting into the sun. That said, when you can work with side lighting, you will find that the exposure is much easier to control.

Family Fun

(bottom) The Ole Miss Softball Complex is a great place to take in a game, and our children are able to get close enough to interact with the players. Our daughter and her softball team attended the game on this night and were out on the field for the national anthem. Our son did a great job of distracting the opposing pitcher with his cuteness during warm-ups. There are some advantages to being in the SEC and in Oxford.

Under Construction

(top) During my first two years on campus, the Student Union was under construction and renovation. It is now open, and I can walk to the bookstore again and also take a caffeine break when needed. The construction fence, equipment, and workers were an ongoing photo distraction as I walked to and from the Student Media Center from my office. I like the contrast between the angles of the scaffolding shadows and the angles of the building.

Flat Tire

(bottom) Jesus may love you, but that does not necessarily mean you won't have to change your own tire.

I am never sure what I will find while out on my bicycle rides, and this scene, on account of the license plate message, was one of the more interesting encounters. It has been a while since I have lived in a state that requires only one license plate, so I

must admit to enjoying the freedom to send a forward-looking message these days. I can happily report that this car was not there the next time I rode past this location.

"Look for opportunities to capture humorous or whimsical moments."

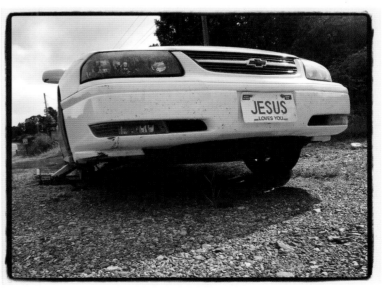

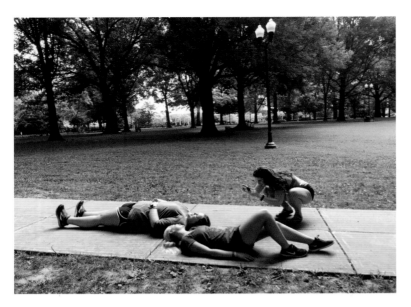

images of each other. More often than not, they make portraits of each other or people they meet. This time, they got a little more creative with their efforts.

Graphics

(bottom) Simple graphics and a shout-out to my childhood favorite game of four square make this image work for me. I was looking at my students' work on the back of their cameras and phones when I glanced down and saw this competition. The hint of sunlight at the center of the crossing lines doesn't hurt either. Clean and simple can speak volumes.

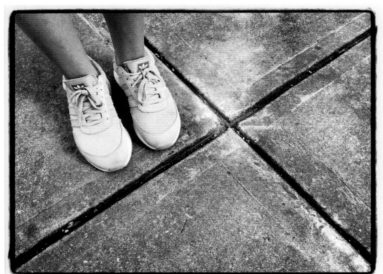

A Bit Unconventional

(top) One of the nice things about having The Grove across the street from Farley Hall is that it is very easy to take one of my photojournalism classes outside to photo coach. It is always interesting to see what students do with the freedom of moving around and making

"Look for clean and uncomplicated scenes to create high-impact photographs."

Ten Tips

1. Shoot from a low angle—or a high one.
2. Look for detail images.
3. Silhouettes can add needed punch.
4. Seek strong and angled shadows.
5. Turn your flash off. I hardly ever use mine.
6. Long-press on your iPhone screen to lock the focus.
7. You can use your volume button for the shutter when holding an iPhone horizontally.
8. Busy backgrounds can be distracting. Simplify. Conversely, look for backgrounds that can help tell the story.
9. Look for and photograph interesting reflections.
10. Don't forget to have fun.

Selfies

Like all overused techniques, selfies get a bad rap from time to time. People accuse those who take them of being egocentric or vain. The reality is that the self-portrait is about as old as art itself. The Masters made multiple selfies back in the day, and no one seems to complain about that.

I like the practice when it's used to mark a moment, celebrate a person, or memorialize a feeling I experienced.

Green Screen

(below) This is me and our son in front of the News Watch green screen used by the weather forecasters. We were both having a good chuckle, and I have even used this selfie as my faculty image for the Lens Collective.

Our little guy is generally very happy. He is often giggling, unless he is hungry, tired, or both. I like that his joy is evident in this image.

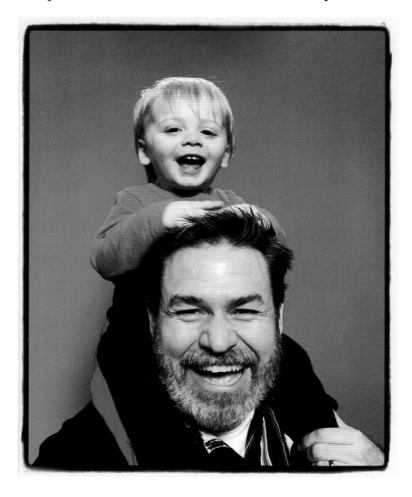

In on the Joke

(top) This is one of my favorite images of my daughter and me. I love the faux Fu Man Chu made out of stickers. My daughter has made multiple beards in our time together, but this one wins, hands down. I like that we tried to play it cool for the camera, though I think my smirk and slight eyebrow raise and her partial smile let the viewer in on the joke. As my daughter grows older, the sarcasm gets stronger in her, and I am sure that I will regret encouraging this comedic strain, just as my parents did.

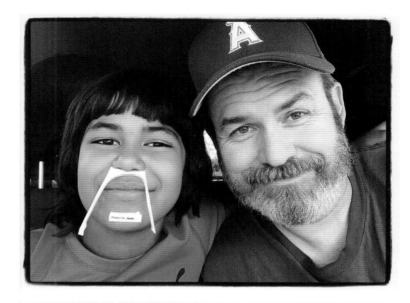

The Whole Family

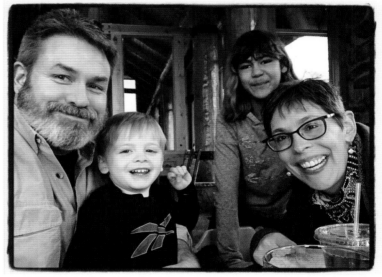

(bottom) Here's my family together in one image. My wife is the glue that holds us together and gets us out on adventures from time to time. This group portrait was made right before dinner at the lodge at Petit Jean State Park in Arkansas. We had just enjoyed a rainy hike down into the gorge to see an amazing waterfall. This may be our season's greeting card image unless we find something better by the end of the year.

"Get a selfie stick or use your iPhone's self-timer to take your solo and group selfies."

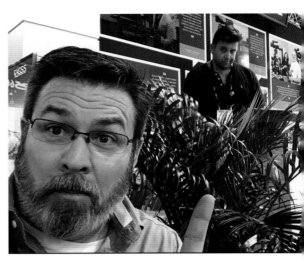

Standing Tall

(left) I am an inch or two above average height. This is a student from one of my photojournalism classes—the starting center on the Ole Miss men's basketball team. *(Note:* This image meets the NCAA regulations regarding using an athlete's likeness.) I could not resist making this photo with him. I told him what I wanted to do visually, and he thought it was funny. What I liked about Dominik is that he sat in the front row, never missed class, and made solid images. He had to slouch so that other students could see the projection screen. He had a fairly good sense about the kind of career he might have and how a visual education could complement it or be his primary work.

Bloom

(right) Found: Philip Bloom, a British filmmaker known for his DSLR filmmaking, blog, and workshops, in his natural habitat at NAB (National Association of Broadcasters) in Las Vegas. I was wandering around the giant show with my colleague, Ji Hoon Heo, and we saw Philip. After I made an image of Ji with Philip in the background, I saw the potted fern and had to make a photograph. Yes, we are both fans of Philip and his work. The thing that had us high-fiving as we giggled and walked away was that Philip looked up and made that face. I tagged him on Instagram, but I never heard anything. He was gracious enough to respond to an email of mine a number of years ago, so I am thankful I had the opportunity to capture this moment.

Series

(below) I am not sure how or why I came up with this series. Perhaps I was happy to be back on the Rochester Institute of Technology campus, in the building I spent many years learning, or maybe I found a remarkable co-conspirator in William Snyder. William is an accomplished photojournalist with a few Pulitzer Prizes in his back pocket, and he is the former director of photography at *The Dallas Morning News*. He is now the chair of the Photojournalism BFA program at RIT. He also has a new book out, *Join Together (with the Band),* which I am probably contractually obligated to mention. Seriously though, William and I had a good time trading stories, hanging out, and getting to know each other again during the Kalish Workshop. I am also glad that he has a healthy sense of humor.

"Shoot a series. You can display them as a group or use an app to produce a montage in a single frame."

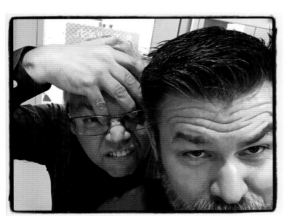

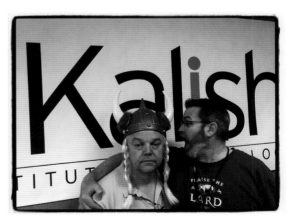

Triumvirate

(top) Just because you are making a selfie doesn't mean that it can't be interesting. Loret Gnivecki Steinberg, bottom right, is my favorite professor I never took a class with at RIT. I have come back to my alma matter to guest teach some of her classes and have spent the night and shared a number of memorable meals at Loret and Michael's (an accomplished author and lawyer) home. Loret has been a quiet mentor, colleague, and friend throughout my career. I like this image because it has friends in it, but also because of the diagonal of our heads and some layering with the "other" Michael's framing between Loret and me.

Dad Humor

(bottom) As I am sure you can guess, I have my "dad humor" moments. One of my colleagues had a course about data visualization, with nothing visual on the digital poster. So, why pass up an opportunity to make a funny image and let my coworker know that something is amiss in the communication? I mentioned earlier that text can distract from the focal point of the image. Yes, there is some text on there, but fortunately, the type is fairly small and my giant head visually holds its own.

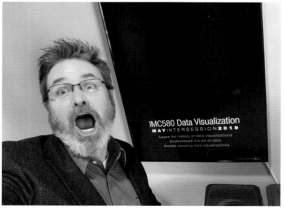

Fast Friends

(top) Two "kids in the candy store" at NAB. Ji Hoon Heo is one of those human beings who can be a colleague and a friend. This image shows the two of us outside the show before its impressive grand opening. I had the opportunity to take a class with him, and he did not disappoint. He and I have some teaching qualities that are similar and many that are different. I enjoyed the unique opportunity to take a class from him, and I am already putting those skills to use.

A Bit of Fun

(bottom) You have probably seen these folks before, and if not, you will see them later. It depends on if you read this book in chapter order. I had to have one more funny image—this one with Ivanka Pjesivac, Ji Hoon Heo, Iveta Imre, and me—before we left for the day. Have fun making images. If there is only one lesson you take away from this book, may it be that one.

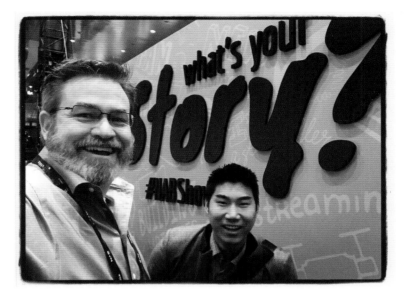

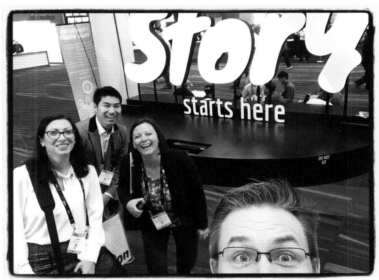

"Have fun while you are making your images. Enjoy the process."

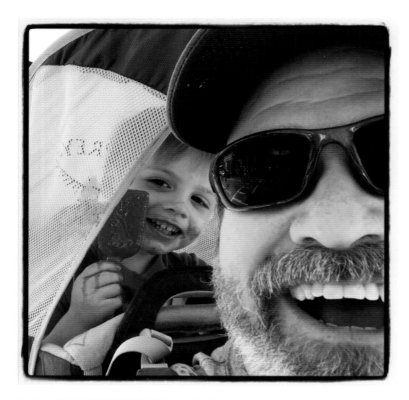

all-natural treats looked like a good choice, despite the potential mess. For the most part, the mess was restricted to my boy's face and the child carrier. I got a little on my back, but I didn't mind. Next year, he will be tall enough to walk by himself in the crowds. For now, this is a better choice.

Camera Man

(bottom) Photojournalist Timothy Ivy is a colleague and adjunct on our faculty. He is a Nikon man, but was checking out another photographer's Canon EOS 80D. We were attending a Mississippi Scholastic Press Association event on campus. We had both made presentations, and I snuck in toward the end of the awards luncheon be-

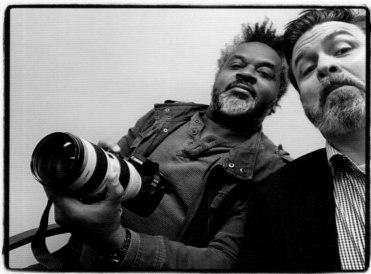

Ice Pop

(top) I took a gamble on an ice pop at the Double Decker Bus Festival in Oxford this year. It was really hot, and the cause my talk had just ended. I am sure that you can figure out which one of us is the more serious.

Little Guy, Big Influence

(top) Gotta love this little man—that smile and that face. I have learned a great deal as a father, and that even influences how I edit and think about my images these days. My boy loves ordering a "chess square" at the coffee shop, and sometimes he lets me have a bite or two. Chess pie is essentially a dessert that folks would make when they lacked the ingredients for a pecan or fruit pie. The recipe for this style of pie, better known outside the South as "crack pie," was published in Christina Tosi's *Momofuku Milk Bar Cookbook*. I have also seen it called an "ooey gooey" bar or cake. No matter what you call it, be sure to get yourself a slice.

Trio

(bottom) A quick selfie with the little man and a professional colleague turned friend, Christina. She has since married and is expecting her first child. We met when I was publicizing my first documentary, and we kept in touch. One day, when we were having coffee and a conversation, she saw the problems some folks were having in finding changing tables and ran a piece on that. She was in love with my son, and I know that she will be a great mother.

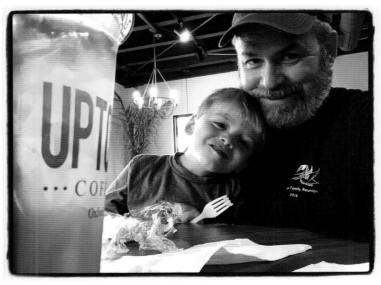

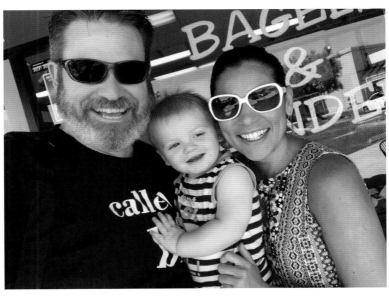

Window Light

(top) Embrace the opportunity to work with window light whenever you can. I had to make an image at the B.B. King

> ## "Be sure to work with window light whenever you can."

Museum & Delta Interpretive Center in Indianola. There are some nice museums in the Delta, and I would put this high on the list, along with the GRAMMY Museum Mississippi, located in Cleveland, MS. This image looks like I had two softboxes on either side of me, but they were just windows. The B.B. King portrait doesn't hurt, either.

Birthday

(bottom) Here I am, hanging out with my wife on my birthday. It doesn't get much better. The co-owner of Tarasque Cucina, Lauren, observed that we even had a blue-and-pink background, so we had no choice but to take a photo. (I kid!) A good meal with good company and conversation goes a long way these days. I know it is not easy being married to a photojournalist. Thanks, Love.

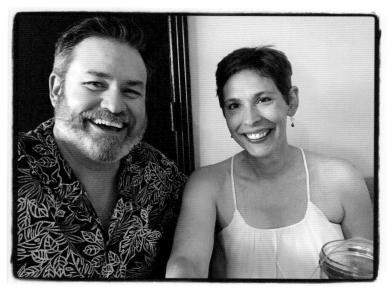

Man in Motion

(top) You can blame my friend Zach Griffin for this cycling selfie. It must have been a cold ride in California because I was wearing my thermals.

I really like the curve of the road arcing out behind my head; it adds a graphic quality to the image.

Yes, you should only take a cycling selfie in low traffic areas and on smooth roads. I don't take too many of these because my phone is usually in a plastic Ziploc bag in one of my jersey's pockets.

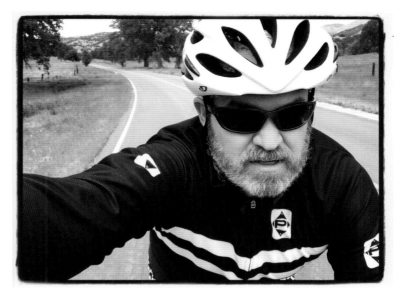

Angel

(bottom) The Idea Hive in Bakersfield, CA, has

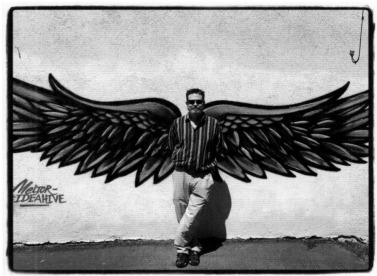

a lovely pair of wings painted on the wall outside their co-working space. I am not sure why my legs are crossed in this image—I think I took some art direction from the owner/operator of the space. Yes, this one has been done before. Heck, they do a variation of this at our daughter's school every year.

That being said, it is still kind of fun. I think a different time of day and softer light might have worked better for this particular photo.

Inject some fun into every day. Embrace opportunities, and enjoy life.

Travel

In chapter 1, I wrote about finding beauty in the place where you live. I truly believe that's important, and though I am a big fan of finding the beauty around me, we do leave home from time to time. Travel provides the means to see a different part of the world—one we might not normally explore, and do something we have not experienced before.

Wherever you go, there you are. Going to a different location does not automatically make you a different person, it just means that you are somewhere else. If you truly embrace the experiences in the place you are, allow new people in, and try new things, then you might start opening yourself up to personal growth or, at a minimum, exploration.

Travel doesn't have to mean planes, trains, or automobiles, though they can help. You can explore your own locale, too. I wrote earlier about how I used to get "lost" on purpose as a daily newspaper photojournalist because I was not sure what I might find.

In this chapter, you'll find images made at the place to which I traveled, but many of the photographs were made when traveling to or from my destination. Some were even made looking away from the things most people focus on.

It has almost become a cliché to talk about seeing with your heart, there is power in the suggestion. Elliott Erwitt, one of my favorite photographers, perhaps says it best: "To me, photography is an art of observation. It's about finding something interesting in an ordinary place . . . I've found it has little to do with the things you see and everything to do with the way you see them."

"Find things you have never seen before and seek new experiences."

A Walk in the Park

(top) The family again. We are at Petit Jean State Park in Arkansas, about to head off onto our epic hike. I often drop back to make images like this. I can't believe that our daughter is almost as tall as my wife, and you can clearly see that here.

I like the way the trees at the top of the image and pavers at the bottom frame my wife and kids. Everything in the photo brings the eyes to the subjects and where they are heading. The little spots of color in the hat and hood don't hurt things, either.

goods (and animals), and even a tax-filing service. Ellis Tanner is the fourth generation of Tanner in Gallup, and at least when I was working in town, he would hold a weekend-long party for his customers.

Saddle Up

(bottom) A lineup of saddles at the Ellis Tanner Trading Post in Gallup, NM. My daughter and I were heading to Mississippi and stopped off at the town where I first worked at a newspaper, *The Gallup Independent.* Trading posts could be pawn shops, a form of bank, a place to sell

Strange Phenomenon

(top) I was flying out of Washington, D.C., after attending my first Association for Education in Journalism and Mass Communication (AEJMC) conference and had just gotten on my flight when I noticed a strange phenomenon overhead. I hoped that this was cold air hitting the humidity in the cabin and that we were not being fumigated. Either way, it was visually interesting, and I managed to grab a few frames before things settled down—figuratively and literally.

Lightning

(bottom) I was flying home when we passed by a thunderstorm and saw lightning in the clouds. I will own up to making a screen grab from a video clip because I could not anticipate when the lighting would illuminate the clouds (a lightning image in my first book was a still capture). Having passed the FAA test for unmanned aerial vehicle (drone) operation, I am now much more informed about the weather formations that cause this activity and the relative dangers to planes.

Window Seat

(top) Always get the window seat—unless you are traveling with your children, and then give them a choice.

I love how the setting sun provides shape and gradation on the wing pylons and the spot color on the winglet.

The atmosphere and feeling of calm I get from this image work with the contrast between the man-made shapes of the wing and the beauty of the clouds. I am sure that I tried multiple framing and exposure options as well as waiting to see what the clouds and setting sun did. Sometimes you just have to be patient.

Los Angeles

(bottom) Los Angeles at dusk, coming in for final approach at LAX. There is something magical about the "city of Angels," as long as you are not stuck in the traffic below. The graphic grid of the city and lights provides a way for our eyes to move through the image. The wing gives us some context, and I like the fact that it is reflecting the last of the blue sky and setting sun as we land.

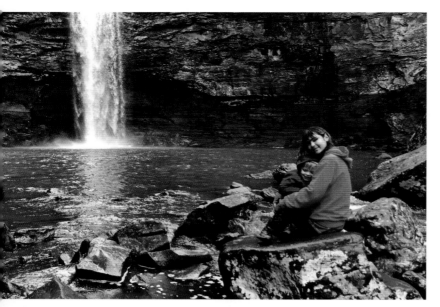

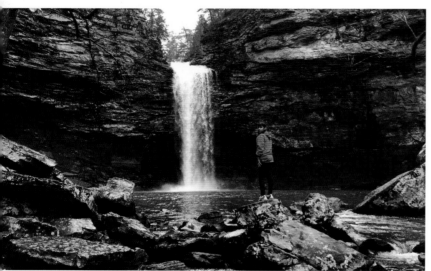

I am sure that my wife dealt with the stress of keeping him alive while I made images. Thank you, Love.

I like having these photos on the same page, as it highlights the way that changing the framing or the subjects can affect the way you see the location.

The blue and pink of the kids' clothes provide nice spot color. My daughter on her own creates a much different emotional feel to the image.

Work the moment and change your perspective and framing so that you have more editing options when you get back to the lodge and dry off.

Photo Sequence

These two photos, made in Petit Jean State Park in Arkansas, feature my two children *(top)* and my daughter on her own *(bottom)*. It's always a pleasure when the kiddos are getting along and enjoying each other's company. It was a struggle to keep the toddler from running off into danger in this location.

"Change the framing or perspective when making multiple images in the same location."

Bridalveil

(top) Bridalveil Fall, Yosemite National Park. The big smile on my daughter's face is due to the fact that we scrambled up to the base of this waterfall in winter. With her strong pose, she exudes self-confidence, something we keep trying to instill in our daughter. This image also documents the beginning of a growth spurt.

We try to visit Yosemite whenever we can. If you have never gone, please find a way. It is truly a cathedral made of stone, and there are numerous reasons why Ansel Adams made so many seminal images there.

Down for the Count

(bottom) Here's the little guy, down for the count. It didn't matter that we were in Yosemite Valley, his body had enough, and it was nap time. I can't say enough about getting a good back-pack-style child carrier (though my son has outgrown mine now).

Chai is so peaceful when he is asleep. I suspect the contrast is primarily for me, because as a toddler, he goes full speed until a nap or bedtime slows him down.

We are trying to instill our love of nature in both our children. We will see if it sticks when they are older.

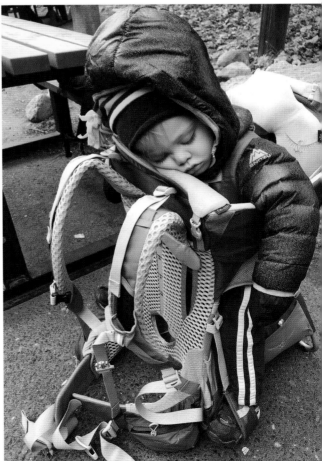

Yosemite Valley Trail

(top) Here is our daughter on a trail in Yosemite Valley. If I have one regret about this image, it is that I did not make a portrait closer to her in this area. I do like the contrast between her size and the giant rock walls of the valley. The trees create a middle ground in the image, but it is difficult to capture the scope and size of this part of the world.

I used the lighter grass of the field in the foreground to help frame my daughter. I think I was able to make a couple of two successful images before the light changed.

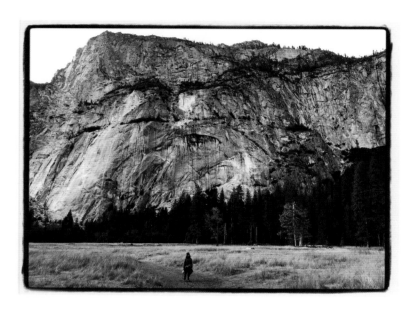

Half Dome

(bottom) This is Half Dome, reflected in the still waters of the Merced River in winter time, though sadly, there was hardly any snow.

I had my professional 35mm gear with me for this outing, but I used my iPhone more than usual because I often had our son and my camera gear on my back.

I have to tell you, it's great to be able to slip a capable camera easily in and out of your pocket, and not to have to rely on heavy gear that can put a strain on your back.

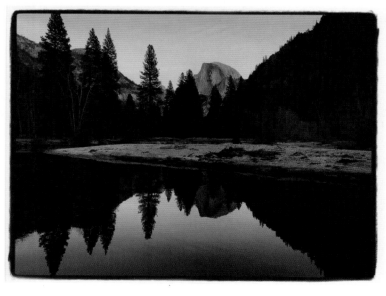

The Art Scene

(top) Photographers seem to be drawn to museums and art galleries like moths to a flame. I suspect that is because the animal we like to photograph the most is in these locations and either focused on the art work or seemingly ignoring it. I like finding tableaus and waiting for people to arrange themselves within the "stage" or walk in or out of the frame. The is the National Portrait Gallery I Smithsonian Institution in Washington, D.C. The foreground, middle ground, and background are all working well tougher here.

Around Town

(bottom) I made this image during my first or second week in Mississippi, though this church is located in Memphis. The Lady Liberty holding the cross makes for a fascinating combination of faith and patriotism. You can make of the message what you will.

"Travel light. Leave your bulky camera at home and learn to make the most of your iPhone camera."

Three Sisters

(top) I just love the incongruity of these three sisters at the Nikon booth at the NAB Show in Las Vegas. I think that nonprofits, charities, churches, and public benefit corporations are learning the role that visual communication can play in rallying community support. As I continue to tell my students, the jobs are still out there—they just may not be where they used to be easily found.

Up in the Air

(bottom) Sometimes you need to make an image just because you like what is in front of you. It doesn't have to be high art or contain layers of meaning. What matters is that it speaks to you.

Esteemed Colleagues

(top) This photo could have gone in the self-portrait chapter, but it fits better in my mind here in the travel section, as it was taken at a national conference. I had an enjoyable time wandering the show floors with my two colleagues, Iveta Imre and Ji Hoon Heo, and a friend of Iveta's, Ivanka Pjesivac, on the far left.

For professors, visual journalists, and broadcast folks, there's nothing like time spent in a giant digital candy store.

Virtual Studio

(bottom) If you have wondered what a virtual studio looks like, you now know. What grabs my attention are all of the sensors on the camera jib arm. Through these, the viewer perceives the movement through the studio that exists only in the computer. There were so many things that caught my eye, imagination, and attention at the show. You don't need fancy equipment to record the world around you. At the end of the day, the best camera is the one you have with you. Remember that, and take advantage of any photo opportunities that come your way.

"Take advantage of any photo opportunities that come your way."

Be Alert to Possibilities

(top) Look around all the time. You never know what you might see. This is yet another photo taken at NAB. This one was made in a booth that was lit almost entirely magenta. You can see from where the bodies blocked the light that the carpet was actually about 18 percent gray. Multiple lights were used,

> *"Look around you all the time. You never know what you might see."*

as is evidenced by the overlap in some of the shadows.

You can probably figure out who is wearing which shoes from one of the previous images from NAB. Like the singer Iris DeMent said, I will "let the mystery be."

Vegas Light

(bottom) This is my last image from the NAB show.

I am always looking for the play of light and shadows, graphics, and the right moment. One of the cool things about Las Vegas is the strong, angular afternoon light. I like the fact that there is a second couple in the background, framed by Ji and Iveta. Repetition is your friend. I also like when patterns are broken; this can heighten a moment.

People Watching

(top) The folks enjoying the display of the Fountains of the Bellagio in Las Vegas were more interesting to me than the fountains.

On a warm night, the Las Vegas strip is a lovely place to people watch and make images. A colleague of mine observed that it might be one of the best things you can do for free in Las Vegas. I can't disagree.

On the Ground

(bottom) In addition to creating photographs in the air, I enjoy watching what happens on the ground outside the airplane. In this case, an early-morning rainstorm, dawn light, and a wet ground all worked together.

Most actions are not repeated on the on the flight deck, so it pays to try anticipate what might happen next and be ready to shoot.

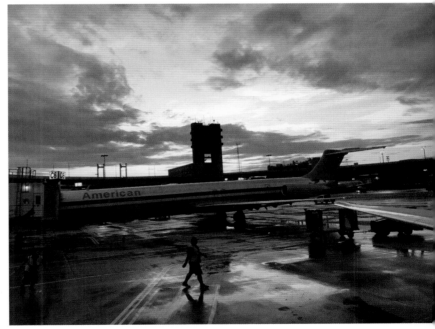

Windmills

(top) I believe we are in Arizona here, but it might be New Mexico. My daughter and I drove out to Mississippi together before my wife and son followed. At the time, we hadn't officially adopted Chai, so life was a little bit complicated. The road trip with my daughter was fun, though it was hard to get her to lift her eyes up from her electronics. Hopefully we will have other trips where we can explore things and make images.

Sierra Nevada

(bottom) The southern end of Nevada does not get the press that the northern end does. What can compare to Yosemite? Still, Sequoia National Forest just south of Sequoia National Park, is breathtaking. My son and I went out for a post-dinner walk, and I captured this image. The trees beautifully framed panoramic image.

Pure Poetry

(top) A simple poem of color. The cyan tone is predominant, but there is a hint of pink, and the two colors play well together. I am a big fan of color theory. There are many reasons why certain colors work well together, and understanding primary colors, secondary colors, and tertiary colors can help you make better images.

Distortion

(bottom) My daughter helped edit this image; it was down to two from the National Gallery. I like that I was playing on the ground and that the shallow moving water became a giant, distorting mirror. I probably could have waited for a more interesting something to happen in the background but I suspect that I had someone waiting for me. There are times I should just, and do, photo wander on my own. Less annoying for others unless it is another photographer hanging out with me and then it can become more fun.

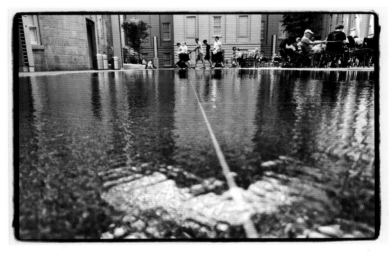

"Study the color wheel and use color theory to produce compelling images."

Visual Tension

(top) I like the way that this tree and Half Dome play off of each other, creating visual tension that draws the eye across the frame. I'm not sure this image is a home run, but it is a solid double, for sure. I also like the warm sunlight on the face of the dome, which contrasts beautifully with the cyan sky.

Almost

(bottom) Looking east from Yosemite Valley, the edge of Half Dome is on the right. I like the strong diagonal leading to the rock face in the setting sun, but this is another image that needs something—like a giant raptor flying through it—to earn an in-the-park home run.

That said, that I was able to capture this image with an iPhone still takes my breath away. I used the touch-screen metering tool to make sure the image was exposed properly for the highlights (the light parts of the image). Not unlike the days of film, with digital, I expose for my highlights.

"Use visual tension to draw the viewer's gaze through the frame."

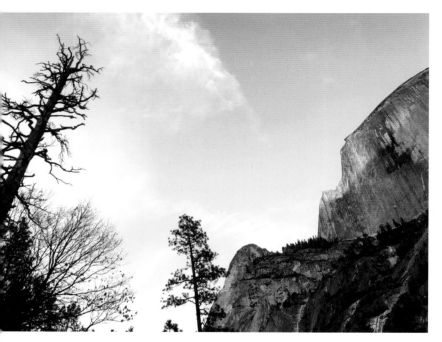

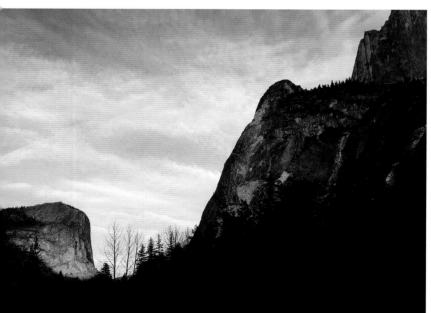

Ten Tips: Apps

1. Try Snapseed. It is my go-to iPhone app for basic adjustments and color corrections.
2. If you have a Adobe Creative Cloud subscription, you can use the Adobe app to do the same things you can do in Snapseed.
3. I used to be a big Hipstamtic fan and I still use it from time to time, though my tastes are changing. The newest version of the app includes all of the tools I wanted, but I have become less focused on the bells and whistles in many apps.
4. 645 Pro and Pro Camera offer manual control over your camera. You can adjust the ISO, shutter speed, and aperture on your iPhone camera as you would on a DSLR.
5. For those of you looking to add textures and other artistic affects, check out the ScratchCam, Pic Grunger, and DistressedFX apps.
6. I like using the Artifact Uprising app to make photo books and print cards from my phone.
7. Instagram is still a great way to share images with people. I even have the feed tied to my web page.
8. You can turn your phone into a light meter with a light meter app.
9. Check out a time-lapse app if you like that effect.
10. I also have Layout, Diptic, Square-ready and Noir apps on my phone. Impression, Big Lens, Superimpose, Laminar Pro, and iResize may be worth checking out, as well.

Kiddos

I initially wasn't going to do this chapter, but rather, something more professional. The more I thought about it, the sillier this excuse became. A number of photographers have documented their families, so why shouldn't I? When I was a student, I thought that my work had to be serious, so very little of my sense of humor showed up in my work. When I started to make funny images from time to time, I found my photography began to loosen up and became stronger. I had been denying a part of who I was, and my work suffered because of that.

I now feel that way about this continuing body of work. I love my children—I usually say *our* children because I want to include my wife in the equation. I love all of the aspects of their personalities, their moods, their quirks, and those moments I want to remember and revisit from time to time.

As a wise colleague once noted, most of my readers may also be taking many images of their families, extended families, and friends, and so they may get more inspirational "mileage" out of this chapter than any of the others in this book.

There are so many good, healthy reasons to take photographs—both serious and funny—of our families. Get on it. Every year, our two children get a photo book of my best images from the year. The toddler can recognize himself in photos, but he doesn't know how to handle his books yet. One of the primary reasons I do this is because we have adopted both of our kiddos, and so I want to provide them with something tangible that they can hold in their hands that will help tell their story.

Our eldest child, my daughter, is still writing her story. There is a script that our children tell each other or family friends about how they came to be part of our mixed-up family. I suspect that script changes over time. I know that our daughter remembers her biological mother and family, and so her story is different from my son's.

The process of growing our family has been an arduous one. If more couples had to go through the process that we did to get certified, we might have

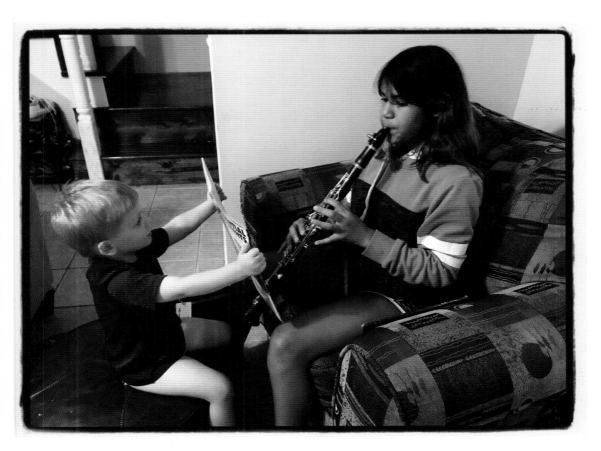

fewer unwanted children. Going to and through the court system was stressful, and I tried to keep in mind how other families experienced the legal system as well.

Adoptive families often celebrate "gotcha day," the day a child officially, legally, became part of their family. Depending on the child's history or age when adopted, that day can be some-what simple to celebrate, or more complicated. Of course, "gotcha day" is one day of the year. Daily, my heart is filled to overrunning when I see our children or they achieve something they have set their minds on.

"Study your children's moods, and capture their personalities. They grow up so fast."

A number of years ago, I thought that being a parent had passed me by, and I had come to terms with that. I am glad that we chose this path and that these two amazing human beings are growing up right in front of our eyes. And yes, there are hard days and difficult moments, but the images in this chapter prove that it is all worthwhile.

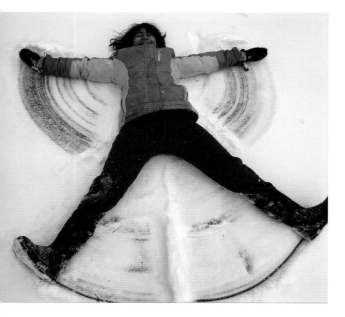

Snow Angel

(top) Our daughter, Nalani, started out as nature girl. Now that she has entered the tween stage, I wonder if that trait will emerge again. We moved from a place in California that experienced no snowfall while we lived there, so even this light dusting of snow in Mississippi was enough to inspire my daughter to run outside and make snow angels. Sometimes, you just have to do that—especially when you are a child. The smile on her face makes the image work for me.

Sleepy

(bottom) This is our son. I don't recall my wife telling me that she had purchased this sleep outfit for him, but when I checked on him the night before I was trying to figure out when he grew a tail. I love the expression on his face as he holds his first juicy water of the day and contemplates waking up. It is very hard to not chuckle when he wears this outfit, and it really seems to speak to who he is.

"Photograph children's silly moments. Some day, they will be only memories."

Long Jump

(top) What might look like interpretive dance is actually a long jump landing along the shore of Lake Michigan. Our daughter is a force of nature, much like the lake itself. No, I am not going to apologize for the tilted horizon, which one of my first photo editors, Greg Dorsett, would object to. Sometimes the image and the moment are more important than making sure that everything is square. I like the energy of this image as is. Sorry, not sorry, Greg.

Adventurer

(bottom) Find a body of water or puddle and guess who will be in there? Way up in the Sierra Nevadas, there are cold streams that can take your breath away and are refreshing on a hot Californian summer afternoon. Farther down the valley, they had to close the river to swimming because the water was so fast and dangerous. This was a smaller stream with a quiet pool where we could cool off and enjoy being cold in the summer. I suspect that my daughter came out of the water only when her lips turned blue.

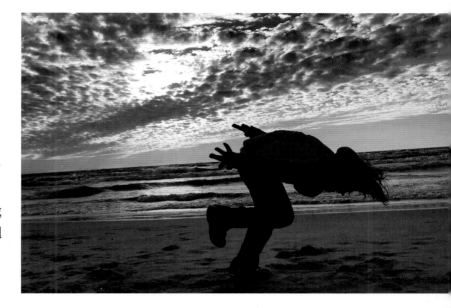

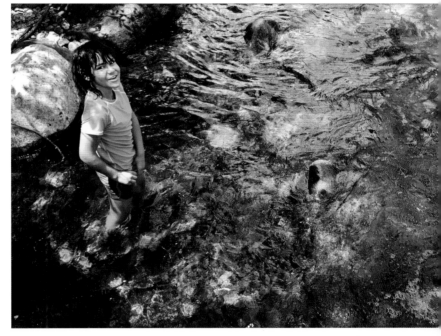

Early Days

(top) This is our not-so-little guy, who was long to begin with—19+ inches at birth. I love this image because it makes me think of cherubs in classic sculptures and paintings. The fact that he is trying to pet Sam, one of our family cats, and the cat is letting him, is endearing. (Chai is much better at petting the cats these days.)

The color in the original image was quite distracting, so I converted the image to black & white to simplify the overall composition and keep the eye on the subjects.

Sweet Potato

(bottom) The sweet potato gangster. I have to admit that I was quite concerned about Chai's hair for a long time—he was my first baby, folks. I enjoyed his nonplussed reaction as I make an image in the midst of his meal. He quickly adapted to real food and my wife became quite the baby food chef over time. If he had a little leather bib with silver studs on it, that is about all that could make this image a bit more fun.

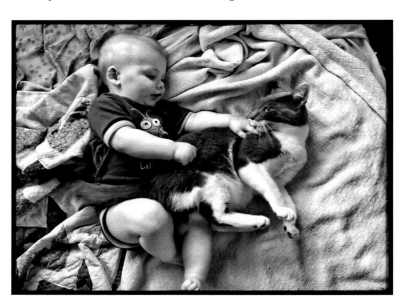

Make Believe

(top) There are times I just don't know what to expect at home. My wife says our boy is going through his industrious stage, and my mother—Grandma—says that I did similar things and looked just as cute.

This is a placemat that has become a bonnet of sorts. Yes, this image was taken right before Christmas, and Grandma knitted three of the stockings hanging on the mantel. Our daughter preferred a store-bought stocking.

Muddy Mischief

(bottom) My wife found this suit on the Internet. It certainly offers great coverage and cuts down on mud stains. Its bright color also makes it easier for us to quickly spot our youngest in the park.

Yep—Chai is pictured here, standing ankle-deep in a mud puddle. He does have rubber boots on, but I suspect that the puddle water still got to his feet. We were at his sister's soccer game, but the little guy was more interested in splash-ing around than he was in the action on the field.

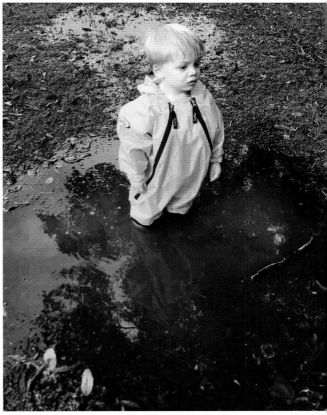

"Document your kids' engagement and sense of wonder when they play, indoors and out."

Playtime

(top) My wife and I are fortunate that both of our families have accepted our adopted children as family, with no debate. This is my mother, going down a slide with our guy at Avent Park in Oxford. A number of friends talked about having a similar image of them with a parent or grandparent. The smiles on their faces is all that we need.

Cuddles

(bottom) During the Christmas break, our guy was not feeling too well, so Grandma and Grandpa embraced their roles and lavished the little man with snuggles. He very rarely stays this still or naps like this during the daytime, but he was definitely under the weather. There's nothing like falling asleep on Grandma's lap.

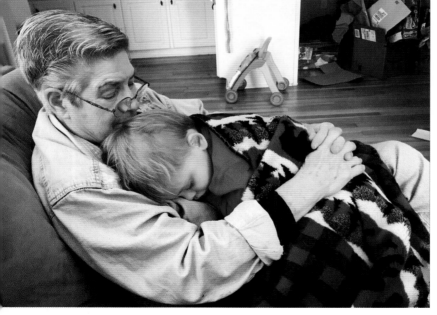

Boxed In

(top) Much like our cats, our little guy loves to climb into boxes and other tight spaces. We can have a good half-hour of fun, folding the box lid and letting him work his way out. Every now and then he tries to bring snacks or food into the box and have a little picnic. I have no words for how cute he can be.

Break Time

(bottom) I took a walk around the neighbor-hood with my son, and he brought his toy lawnmower along. At one point, he decided he needed a break, so he pushed his toy to the edge of the sidewalk and sat down beside it. He truly looks worn out from a hard day on the job.

Simple graphics help this image, but a boy and his toy mower do most of the heavy lifting here.

Dancing

(top) Here's our boy, doing some sort of dance in his Star Wars Crocs as the sun set in our neighborhood in Oxford. I love how the sun provides some wonderful edge light that calls attention to his body language. The sidewalk provides a strong diagonal line that gives depth to the photograph. I am blown away by how well the iPhone's sensor captures those individual blades of grass.

Moments like this, I just sit back and smile—well, after I have made some images. Priorities!

Hide and Seek

(bottom) Guess who hid in a colleague's storage closet during a visit? That little foot sticking out cracks me up.

We adopted our daughter at age 5, so the antics of a child aged 1–4 were new to me when our son came along.

"Photograph children from your height and theirs, as well as from varying angles."

Jersey

(top) Grandma and Grandpa grew up along the Jersey Shore, just north of Asbury Park, so most family reunions are on the Atlantic or Pacific coast. We do have beaches in Mississippi, so we shall see if the Gulf of Mexico gets factored in to the picture some day. This summer, we were in Maine and the little guy could not get enough of the beach, sand, and anything he found on the walk to and from the beach. The wind in his hair, his smile, his running, and the beach sum up this reunion for me.

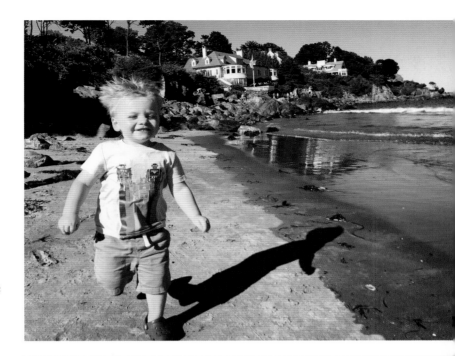

Story Time

(bottom) When I worked with the United Way of Kern County, I learned about the importance of reading to children and cuddling during story time. Della Hodson, CEO and president of the board, and Rachel Hoetker were tireless in promoting the Born Learning Program.

One day, I came into our bedroom and found our little guy looking through his books, turning the pages all on his own. It looked like he was engaged in some very serious Sandra Boynton research.

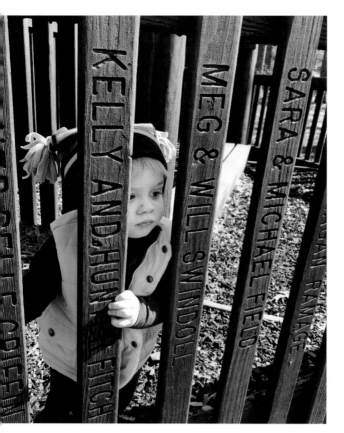

Dapper Duds

(top) My wife finds the most amazing and photographic clothes for our children to wear, and she has an uncanny ability to find outfits that fit their personalities. This image was made at Avent Park, in some glorious late-afternoon light, which fell onto a grid of wooden planks in the children's section of the park. The gesture of the boy's hand on the board, the yellow from the jacket, and that delightful striped hat ensured that this image fired on all cylinders.

Keen Observer

(bottom) From a very young age, our son began copying me, holding various objects up to his eyes like a camera. My wife noticed this before me and had to point it out. I now better understand why so many children of photographers—famous and not—follow in their parents' footsteps. Children mimic and model so much of our behavior, and that experience can cause them to form powerful connections to an activity.

My wife, when seeing our son mimic my behvior, asked, " You let him hold the good camera?" Yes, I did—with my hand underneath it.

"Instill a love of photography in your children. It's a great bonding opportunity."

Gotcha Day

(top) Gotcha Day! I have to admit that I was humming the Talking Heads' song, "Once in a Lifetime" when the little man got tired of behaving as we waited to go into the court room to finalize his adoption. I am not sure if he knew the importance of the day or why he was wearing a tie. I suppose we will have to help him craft this chapter of his story someday.

The Wrap-Up

(bottom) We were lucky to be surrounded by friends, family, and coworkers when the adoption of our son was finalized. Whether a child is adopted from another country or from out of state, there is a lot of legal maneuvering that precedes the "all clear." Judge Vega, who presided over both of our children's cases, is on the left. He did not finalize our daughter's adoption, but we had a chance to talk on this occasion.

Fast Friends

(top) Here's another image of our son, at 3 months, with our cat, Sam. The two appear to be sizing each other up, though Sam seems to have a better sense of what is going on. I used a bit of an edge blur to keep our eyes in the middle of the frame and the interaction between these two new friends.

Peapod

(bottom) This is my Anne Geddes tribute image. Once again, my wife found the Halloween costume of the year for our 1-year-old son. I suspect that this image will make an appearance in a slide show the night before his wedding. Some family traditions need to be maintained. I still can't believe we dressed him up like this, but what a cutie!

Conquerer

(top) I really like this image, and the back story. This playground is within walking distance of our rental house in Oxford, so we visit it fairly regularly. Chai had been afraid to slide down this piece of equipment for some time. One day, he began to climb up the slide from the bottom. Soon, he was getting the hang of it, and I moved up to the top to see how he was doing and snapped a photo.

His dark clothing provides visual separation, and the red stars on the adorable pants my wife selected tie into the color scheme. His body language and climbing technique are spot-on; with the translucent slide and back lighting, everything comes together for a magical image.

Framing

(bottom) Our guy is a climber and explorer. You may have noticed by now that I am a fan of framing devices and lines that divide the frame in different ways

"Use diagonal lines to create a dynamic feeling in your image."

and break up the horizontal frame. I like his body language, engagement with the camera, and his pride as he shows me what he can do.

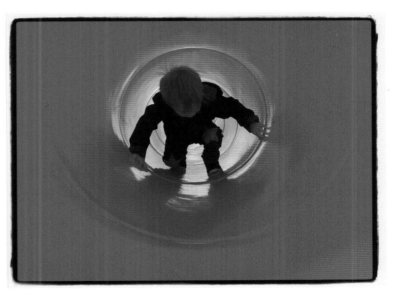

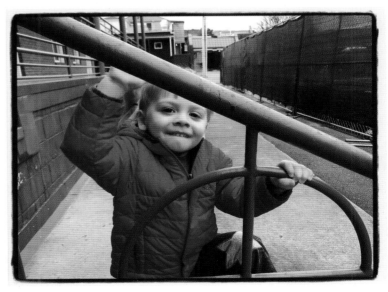

Siblings

(top) Petit Jean State Park in Arkansas, again—this time in the Bear Cave area. Another portrait of the two kiddos. Our daughter is protective of her younger brother, even as he can annoy her like no other person in the world. That is true for all siblings in the world, I suspect. Their pose feels like the top or bottom of a totem without a pole. I am a big fan of letting people sit or pose comfortably, not directing them how I think they should act. I feel like they settle naturally and give me and the viewer a glimpse of who they are.

A Born Leader

(bottom) Here is our daughter, Nalani, with one foot in childhood and another leaning toward adulthood. I don't think that my generation, and folks who are older than me, are quite ready for how young women will be approaching life and ignoring the boxes society will try to put them in. We have made sure that Nalani has earned Taekwondo belts, she has a bat the equal of any young man her age, and she is fearless in the batter's box. She has leadership skills and will not be letting any young men talk over her. Yes, as a father, I see all of that and more in this image.

Adventure Boy

(top) Adventure boy at it again. He is generally fearless and becoming more so as he gets his coordination under control. I suspect he will be too much like his dad, so we will have to work on the lesson we taught his sister; keep track of how you got up there so that you can climb back down. We would very rarely lift her out of tricky situations, we would help her climb down or remember how she got up there. We would spot her but not do the heavy work.

Work in Progress

(bottom) There are times I feel like I am trying to cram too much into my children's days because there is so much I want to share and teach them. I am learning how to be patient, to let the lessons come to us in the right time. I am learning how to be a better father, and they are teaching me, thankfully. There are days I feel like I am just trying not to screw things up, but I suspect that most parents feel that way too. Oh, I make plenty of mistakes and am immensely human and made of clay. Fortunately there are enough laughs and smiles to get us through the darker times. The good news is that tomorrow is a new day and we can try and get it right again.

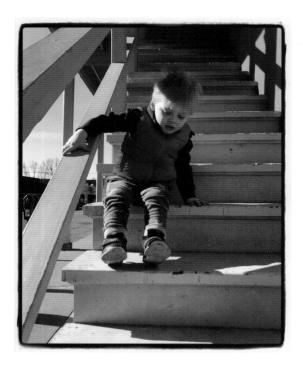

Magical Morning Light

(left) My son is an interesting mix of adventurous and cautious. Now that he is 3 years old, his adventurous side seems to be taking over.

I enjoy walking in the square in downtown Oxford and taking photographs—especially when I can take advantage of magical morning light. There's nothing quite like it.

I know many photographers who work in the morning and late afternoon, when the sun is lower in the sky and

"Print images of your favorite memories for display, as well as for posterity."

produces directional light. Many folks nap and work on their photos in the middle of the day. Yes, there are times when you'll have to—or be compelled to—take images when the sun is directly overhead, but the lighting won't have that wonderful directional quality, unless you use flash.

The Spaghetti Incident

(right) Grandpas get to do all sorts of fun things. Here, the little man is enjoying some pasta, fed to him by my father. When I saw this action unfold, I wondered if that was something he did with me when I was a kid. I am not sure whether or not I will get to be a grandfather; time will tell—but I am glad that I have been able to be a dad.

I am trying to document and store an array of moments—special and mundane—so that we can relive them when our kids reach their teenage years.

Overcast Skies

(top) Here is one of my recent favorite photos of our son. We were picking his sister up from summer camp and wandered down to the lake to check things out. A storm was coming in, so we had cloudy skies and nice, even light.

When I look at this image, I can say that I understand why people refer to children's age in terms of months; it's because things change so quickly. Our boy is becoming his own person, and is more self-reliant every day. I wonder what he will be like when he grows up.

In Touch with Nature

(bottom) Here is our curious kid, studying worms and insects on the sidewalk, post rain storm. His concentration and interest—both in this scene and in everyday life—are impressive to me.

Ten Tips

1. When kids say no, listen to them. It breaks my heart when my daughter doesn't want to be photographed, but I don't want to annoy her. I used to make images of her all the time. These days, I am more likely to look at *her* images and offer kind feedback rather than have her in front of my lens.
2. *Always* be ready. (Well . . . within reason.)
3. Composition is important. Think about the way your eyes—and a viewer's eyes—will move around an image. Kids move fast, so you might not have a lot of time to quickly capture an effective composition. However, if you practice photograph-ing non-moving or slower-moving subjects, creating strongly designed images will come more naturally.
4. Keep an eye on your background.
5. Keep an eye on your background. (No, this isn't a typo—scanning for distractions is that important.)
6. Children and animals are the hardest subjects to photograph. Always keep that in the back of your mind. Be patient, and practice.
7. You don't have to tell the whole story with one image. You have time. Don't worry about missed moments.
8. Photograph your kids as they are, not as you might want them to be.
9. Get down on their level.
10. Natural light is your friend.

Personal Vision

When I was studying photojournalism at the Rochester Institute of Technology, Professor Gunther Cartwright offered a class called "Personal Vision." In school, many of us struggled to develop our own personal visions. Perhaps we were "trying on" other photographers' styles and enjoying their influences. I passed the class, but as I have written before, I didn't realize the importance of developing my own voice as a photographic artist until later in my career.

I think my personal vision comes down to photographing the things that catch my attention in the world, and finding ways to depict what my eye sees. In time, I've come to develop a growing body of work that speaks to my personal aesthetic in picture-taking.

My advice to you is, take pictures. Practice. Enjoy shooting. It may not happen right away, but you *will* begin to develop your own artistic style. Notice what it is that catches your eye. Pay attention to the things that move you emotionally, the moments that make you laugh out loud, and what it is that you care about. Make some interesting images.

There are some photographers, like Sebastião Salgado or Elliott Erwitt, whose work you can easily recognize before you even look at the photo credit. That's impressive, when you think about it. As photographers, we love the new and different because we have seen so many images over and over again. Internationally acclaimed choreographer Garth Fagan tries to put a movement into each of his pieces that has never been made before by a human being.

I am not at Mr. Fagan's level yet, but I do try and go out and see the world, constantly refining my eye and vision. I push myself to explore, to get lost, to play, and to create—to make great images. I hope you will get out there and do the same.

A Sense of Place

(top) *Washington Post* photojournalist Michael Williamson spent some time in Mississippi not long ago and made some amazing images. I showed them to my classes and informed them that he had set the standard for images made in our state. This is *my* first image made in Mississippi. I tried to capture the sense of mystery in this scene. I wanted to depict the heart, soul, and beauty of the place I now call home.

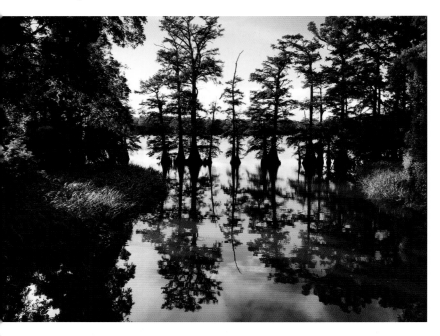

Silhouette

(bottom) I met Ron Erdrich at the Kalish Visual Editing Workshop, and we were suite mates in the dorm we stayed at. I like how the tilt of the frame plays against the body language that Ron is vainly trying to apply to his bowling ball. The lanes and the grid of the ceiling are working to frame the subject, and we can all identify with what Ron is attempting to do and the futility of the action.

Moments in life that we can recall, something many of us have experienced, bring layers of meaning so that sometimes, as photographers, we don't have to do any heavy lifting.

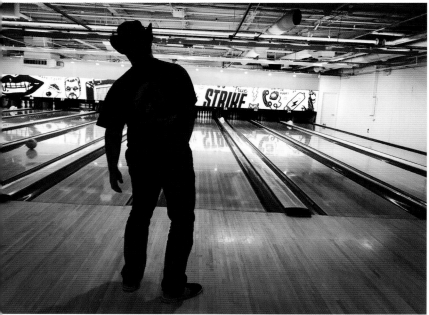

A Muse

(top) Elliott Erwitt is perhaps one of my biggest photographic role models. I have yet to meet him, and I had better get my hustle on if I am going to make that happen.

I have fully embraced working a sense of humor into my work; without it, I believe that I am pretending to be serious. Sometimes I have to make frames that make me chuckle, even if no one else, especially my family, laughs. Yes, we know where the rest of the worker's body is, but there is still a little mystery in this image. The empty hall and spot color of the ladder help to make this image successful.

Cat Nap

(bottom) This young man took a cat nap in the lobby of our hotel during the AE-JMC Conference in Washington, D.C.

I don't mind the type on his shirt. I feel it adds to the image. I played with being farther away, but I lost the sense that he was asleep.

I hope that his presentation or class work went well. To fall asleep in the lobby, he must have been exhausted.

"Take inspiration from the work of renowned photographers."

"Learn the tenets of photography and break them for effect from time to time."

next. I kept trying to play with the contrast of people and the video images, but it wasn't working. I pulled back and started to work in the water and reflections. In one sense, this is one of the least interesting screens that showed, but it provided an even color cast to the image that worked well with the reflection and the graphic qualities of the architecture.

Rebellion

(bottom) Bend those rules and guidelines of photography whenever you can. I love how the window frames mimic the Rule of Thirds guides, but I threw that rule out of the window by positioning my subject in the center of the frame. I also like how the weathered windows and overcast sky help throw the background into soft focus.

This is a scene we can all relate to. We have all made a phone call in a public space. There is also the shared experience of gazing at something we want but we are separated from, perhaps by a barrier.

Don't let the "rules" get in the way of making the best image you can.

A Touch of Tech

(top) These video screens in Washington, D.C., gave me fits. I spent a good hour or more trying to make this image work. Part of the problem is that the scenes cycle through infrequently enough that it is hard to predict what is

Viva Las Vegas

(top) The first time my wife and I visited Las Vegas, we couldn't escape fast enough after my meeting was over. I was younger then. I do like the city for making images. It is a beautiful city, at least around the strip, but so often I feel that the beauty is only on the surface.

In this case, the perspective my hotel added to the existing cityscape and construction appealed to me. The time of day and strong diagonal of the road enhanced the composition. I hope that despite my feelings, there is room for you to bring your own experiences and thoughts to the image, and that it works for you in different ways.

this moment, pulled out my iPhone, and grabbed some frames quickly, only to see that my camera lens was dirty, probably with oil from my body or hand. I think this image works because of the blur, so I am happy to let the serendipity play out. I did clean the lens after this, despite a successful accident.

Lens Flare

(bottom) One of my first lessons in my photojournalism class is that the lens cleaning cloth is your friend. I am usually on top of keeping my lens clean. I was returning home via the Memphis Airport when I saw

Contemplation

(top) Here is another image taken at the National Portrait Galley. This one was made in the Gallery for Folk and Self-Taught Art, with Lonnie Holley's "Yielding to the Ancestors While Controlling the Hands of Time" in the background. I like the play of the strong silhouette of the viewer encountering the Outsider Art from Alabama. I also like that the viewer's shadow is stronger than the art work's on the gallery floor. The centered composition of the image is weighted left, with the gallery guest providing visual balance to the image.

Motion Blur

(bottom) One of the "dirty little secrets" of photography is that people walking past will often look in the direction photographers are pointing their lenses. I suspect that it is human curiosity, though following another's gaze is probably also a learned trait that served our ancestors well a long time ago.

Here, the framing device of the door draws the viewer's eyes to the Titus Kaphar canvas off the main hallway. The movement blur of the person walking past does not pull our eye to them, and their attention helps direct the viewer's eye, too. Add in that Kaphar does some interesting and eye-catching things to his work. All of these elements combine to make this image a success.

Poingant Portrait

(top) This isn't a complex image; it is a political statement, I suppose—a homeless person sleeping on the sidewalk in front of a business with a God Bless America sign. We have a homeless problem in our country, and a significant portion of them are veterans. Having worked with nonprofits and churches who were trying to address the needs of the homeless in Bakersfield, I am more than informed on the complex web of situations and factors that lead people to live this way in our country. I hope that we might, at the very least, have compassion and empathy for our homeless sisters and brothers.

Christmas Time

(bottom) A Jersey boy—myself—watching another Jersey boy tell his story on TV, as my son rides his rocking horse in our living room at Christmas time. This image got picked up off of Instagram and run on the Star Ledger thread—but I never read the comments. I use the Boss' lyrics as one of my teaching tools when I cover digital storytelling in class.

I had wanted to go see the Springsteen show on Broadway, but I did not have the money or the opportunity. So when the show came to Netflix, I watched it as soon as I could. To have

"Document social concerns that affect your city or town."

my son in the room made this a special evening, and an event I had to document. (No, the kid wasn't going to sleep easily on this night.)

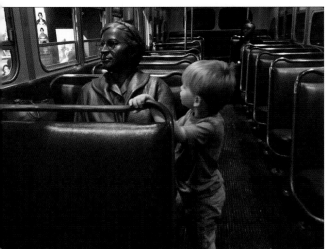

for the viewer. And yes, perhaps I am editorializing a lot, but I am OK with that. Hopefully you chuckled when you first saw the image.

Curiosity

(bottom) Hopefully we can all approach life with the curiosity and lack of guile of children. Here my son gets up close with Rosa Parks on the bus exhibit at the National Civil Rights Museum in Memphis. I am sure that he is too young to understand the story in all of its complexity and I am fine with that. We try to expose our children to our country's art and history so that they have a better sense of where we have been, where we are heading and what we can hold up and celebrate (and what she might want to mourn). I was mostly on toddler herding duty that day, but his being there and interaction with many exhibits brought smiles to people's faces at a place a good friend told me that they found profoundly moving emotionally.

Java

(top) This is another example of my sense of humor. It makes me wonder why this poor coffee urn was standing off all on its own, apart from the other coffee containers. Yes, we know it is the decaf coffee, but why should that stop us from wondering about the internal emotional life of the non-caffeinated?

I like when patterns are broken in images and the questions that might raise

Ansel-Inspired

(top) Ansel Adams was probably the first photographer's name I learned. Many years ago, before I went to RIT, I thought I would be a nature photographer like Galen Rowell and Ansel Adams. Then I got a job working for our school newspaper and got the photojournalism "bug." I never looked back, but I still like to go out and make images in nature. I just don't try to earn a living from it. Having learned how to operate a 4x5 camera and hand-process black & white film, I am still blown away that I can make an image like this on a phone that I carry in my pocket.

Zen

(bottom) A boulder in Mirror Lake at the foot of Half Dome in Yosemite Valley was my visual playground this day. When I composed the image, I avoided dividing the frame equally with the horizon line. I like how the patterns along the bottom of the lake become more obvious at the bottom of the

frame and the boulder contrasts nicely with the trees in the background. This is a very peaceful, Zen image for me.

First Flood

(top) I made this image during my first experience with flooding in the Mississippi Delta. Getting low helped with the perspective and draws attention to the way the road abruptly becomes covered by water. The compositional simplicity aids the storytelling aspect of the shot.

As the southern end of the Delta is dealing with flooding in 2019, this image hints at the future and refers to the past. The question for the Delta is not *if*, but *when*, it will flood again. The Great Flood of 1927 is on people's lips this year. Faulkner was right: we must understand Mississippi to understand the world.

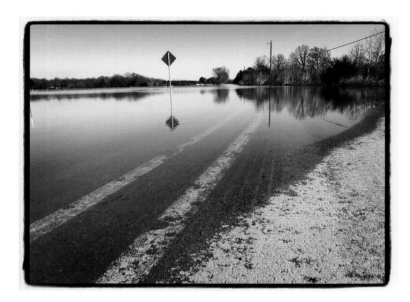

Frigid

(bottom) A frosty morning greeted me as I dropped our son off with his babysitter. I tried framing this image a bunch of different ways, but I ultimately decided to contrast the barbed wire with the trees in the background. The overcast skies and frost lend a duotone look in the photograph.

I learned a long time ago to make images when the moment presents itself. Nature won't wait for us. Seize the moment, make the image, and apologize to folks if your need to capture moments leads you to run late.

Man versus Nature

(top) This may fall into the "almost" category, but there are a number of things going on that work for me. I really like the contrast between the tree and the brick wall, the hue of the red paint, and the natural lines versus the man-made brick. I think this image is a solid double or triple, but not a home run. I probably should have spent more time here or used my DSLR camera, but that would be cheating. All too often, I see scenes that I know I could nail with a long lens, but that is too easy. It is more fun to try to figure out how to make the wide-angle lens of the iPhone work.

Blur-o-Gram

(bottom) RIT Professor Gunther Cartwright would call this a blur-o-gram. Photographers often get caught up in determining what should be in focus or out of focus in the frame, and why. These are good things to consider. However, making blur the prevalent aspect of the image may be an approach that is underused.

I like this image for the emotion it evokes in me. (Yes, Gunther, the wall in the background is in focus, it is just really difficult to see.) It has an abstract feel. It's hard to make out the subject. In fact, this is window light cast in a stairwell in Farley Hall in winter time.

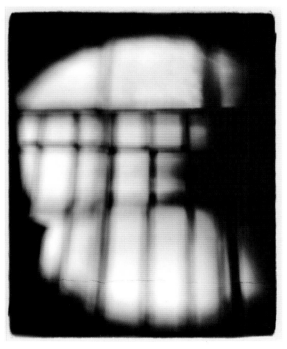

"Push your creative boundaries. Add some abstract images to your collection."

Examine your world. Notice how the light changes through the seasons.

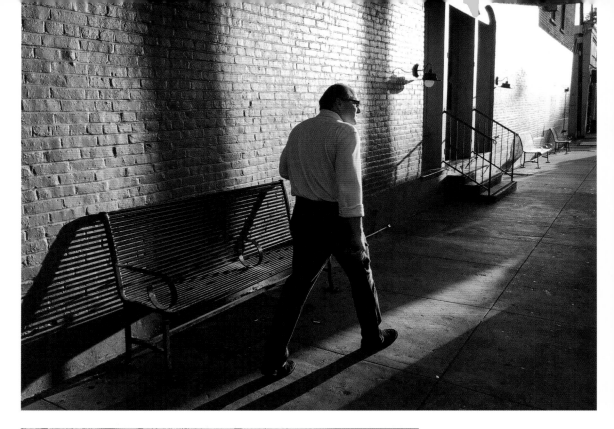

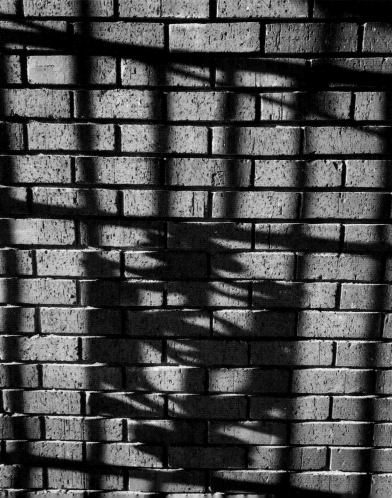

Street Photography

(previous page, top) In Oxford, we don't have the spectacular buildings some other cities or towns do, but we get lovely evening light when the weather is right. I found this great spot and waited for the right person to walk past. I love the long shadows and the edge light. The subject's physical step matches the light, and he is framed by the light on the wall behind him. This is probably a "photographer's photograph," but I can live with that.

Good Grids

(previous page, bottom) Grids are good. In this image, I enjoy how the brick grid, which is in sharp focus, contrasts with the softer-focused shadow from the wrought-iron gate. The warm color from the setting sun the shadow interplay caught my eye as I was walking back to my car from dinner.

Don't hesitate to capture an image when you see something that catches your eye. Coming back rarely works. Take advantage of what is around you, and seize the moment.

"Seize the chance to capture an image then and there when a scene catches your eye."

Ten Tips

1. Don't rush through your image-making. Sometimes, capturing a great image takes time and repetition.
2. Look back at your work from time to time. Notice the things in your work that catch your eye.
3. Study other photographers' work, especially people whose styles resonate with you.
4. Find someone on Instagram who makes street photography images.
5. Commit yourself. Make one image a day for a year. At the very least, make one image a week.
6. Find a photographic mentor. Show them your work regularly.
7. Attend a photo workshop, weekend, or trip.
8. Get out of your image-making comfort zone.
9. Learn to see with more than your eyes.
10. Now that we've reached the end of this book, this tip bears repeating: Don't forget to have fun!

Index

A

Abstracts, 123
Adams, Ansel, 83, 121
Aperture, 95
Apps, 93
Architecture, 48

B

Backgrounds, 67, 85, 112
Black & white, 50, 55
Blessing ceremony, 5, 6
Blur, motion, 118

C

Catchlights, 44
Close-ups, 13, 14, 17
Color, 8, 9, 11, 12, 15,
 31, 79, 81, 82, 91, 123
Color wheel, 91
Composition, 8, 9, 12,
 15, 16, 31, 40, 44, 63,
 65, 79, 84, 112, 116,
 121, 122
Contrast, 9

D

Depth, 46, 48, 102
Detail, 67
Drones, 26, 29, 80

E

Editing, 19, 26, 50
Erwitt, Elliott, 78, 113,
 114
Exposure, 61, 64, 81, 92

F

Flash, 67
Focus, 67
Food, 36–40
Foreground, 84, 85
Framing, 9, 31, 40, 46,
 79, 82, 107

G

Golden hour, 33
Graphic images, 30, 35,
 39, 46, 77, 81, 88, 101
Grids, 31, 104, 114

H

Highlights, 92

I

Instagram, 95, 125
ISO, 95

K

Kids, 94–112

L

Landscapes, 15
Lens, 28, 117
Lens flare, 117
Light, 11, 12, 14, 17, 23,
 33, 36, 40, 43, 44, 48,
 49, 60, 61, 62, 64, 65,
 67, 76, 81, 88, 104,
 107, 110, 112, 123
Light meters, 95
Lines, 9, 16, 46, 92, 102,
 123

M

Maisel, Jay, 5
Manual exposure
controls, 95
Mentors, 43
Middle ground, 85
Mississippi, 47–67
Murals, 30

N

Newspapers, 5, 57, 78,
 79, 114

P

Panoramic images, 24
Patterns, 46
Patton, Charley, 52

Personal vision, 112–25

Perspective, 36, 61, 67, 102, 112

Photojournalism, 19, 23, 29, 30–35, 42, 56, 71, 74, 78, 117

Portraits, 22, 41–46

Posing, 108

Practice, 19, 113

R

Reflections, 62, 67, 84, 116

Repetition, 88

Rule of thirds, 46, 116

S

Self-assignments, 9

Selfies, 68–77

Selfie stick, 69

Self-timer, 69

Series, 71, 82

Shadows, 33, 62, 65, 88

Shapes, 9

Shutter speed, 95

Silhouettes, 8, 23, 67, 114

Snapseed, 93

Street photography, 35, 125

Sunset, 62, 81

Symmetry, 44, 60

T

Tension, 92

Text, 57, 62, 72, 115

Texture, 9, 95

Time-lapse, 95

Travel, 78–94

W

Workshops, 31, 43, 52, 56, 71, 114

Wyeth, Andrew, 51

AmherstMedia.com

- *New books every month*
- *Books on all photography subjects and specialties*
- *Learn from leading experts in every field*
- *Buy with Amazon (amazon.com), Barnes & Noble (barnesandnoble.com), and Indiebound (indiebound.com)*
- *Follow us on social media at: facebook.com/AmherstMediaInc, twitter.com/AmherstMedia, or www.instagram.com/amherstmediaphotobooks*

Create Pro Quality Images with Our iPhone Photography for Everybody Series

iPhone Photography for Everybody
Black & White Landscape Techniques

Gary Wagner delves into the art of creating breaktaking iPhone black & white landscape photos of seascapes, trees, beaches, and more. $29.95 list, 7x10, 128p, 180 color images, ISBN 978-1-68203-432-3.

iPhone Photography for Everybody
Creative Techniques

Beth Alesse teaches you how to combine expert iPhone shooting techniques, artistic vision, and popular apps for next-level images. $29.95 list, 7x10, 128p, 160 color images, ISBN 978-1-68203-449-1.

iPhone Photography for Everybody
Family Portrait Techniques

Neal Urban shows you what it takes to create personality-filled, professional-quality iPhone family portraits. $29.95 list, 7x10, 128p, 180 color images, ISBN 978-1-68203-436-1.

iPhone Photography for Everybody
Landscape Techniques

Barbara A. Lynch-Johnt provides all of the skills you need to master landscape photography with any iPhone. *$29.95 list, 7x10, 128p, 160 color images, ISBN 978-1-68203-440-8.*

iPhone Photography for Everybody
Still Life Techniques

Beth Alesse provides creative strategies for artfully photographing found objects, collectibles, natural elements, and more with an iPhone. $29.95 list, 7x10, 128p, 160 color images, ISBN 978-1-68203-444-6.

iPhone Photography for Everybody
App Techniques—Before & After

Paul J. Toussaint shows you how to transform your iPhone photos into fine art using an array of free and low-cost, simple apps. $29.95 list, 7x10, 128p, 160 color images, ISBN 978-1-68203-451-4.